PABLO PICASSO
A Modern Master

Richard Leslie

TIGER BOOKS INTERNATIONAL
LONDON

DEDICATED TO THE MEMORY AND LIVING HOPES OF MY PARENTS
JOHN EARL LESLIE *AND* MARION EILEEN LESLIE.

This edition published in 1996 by
Tiger Books International PLC, Twickenham

This book was designed and produced by
Todtri Productions Limited
P.O. Box 572, New York, NY 10116-0572
FAX: (212) 279-1241

Printed and bound in Singapore

ISBN 1-85501-834-9

Author: Richard Leslie

Publisher: Robert M. Tod
Editorial Director: Elizabeth Loonan
Book Designer: Mark Weinberg
Production Coordinator: Heather Weigel
Senior Editor: Edward Douglas
Project Editor: Cynthia Sternau
Assistant Editor: Donald Kennison
Picture Researcher: Laura Wyss
Desktop Associate: Paul Kachur
Typesetting: Command-O, NYC

CONTENTS

INTRODUCTION

The word genius, like the word masterpiece, is overused and its application much debated. But one figure's "genius" has been nearly universally agreed upon: Pablo Diego José Francisco de Paula Juan Nepomuceno María de los Remedios Cipriano de la Santísima Trinidad Ruiz Picasso, or, as he eventually signed himself, "Picasso." Like the birth and life of a mythological figure—a position he accepted for himself as an embodiment of creativity—he remains surrounded by legendary exploits and apocryphal stories.

Picasso's mother recounted his first words as *piz, piz*, an abbreviated form of the Spanish for pencil, *lápiz*. The implication that the child genius could draw before he could talk seemed verified later by the thirteen-year-old who mastered the drawing of the human body and by the man who all his life filled notebooks with sketches. There is the oedipal story of the young Pablo Ruiz (this is how he signed his early work, after his father's family name) who made such quick progress under his father's tutelage at art school that Don José gave up his own palette and brushes to his son, swearing to abandon painting forever. This occurred around 1894, when Pablo was thirteen, but his father continued to paint as well as teach. More reliable but equally prophetic are the reports of the young Pablo, now fourteen, blazing through the advanced exams for classical art and still life in the Barcelona art school. They were to take a month to complete; he finished in a day, or a week, depending on the source.

Common to all apocryphal stories is their writing after the fact, to celebrate the event of something or the conduct of someone worthy of the myths and near-myths, and, equally important, our need to have them. Measured by story, deed, ego, or need, Pablo Picasso remains one of the great legends of the Western world.

Self-Portrait

1901, oil on canvas; 31½ x 23⅝ in. (80 x 60 cm). Musée Picasso, Paris.
Monumental figures rendered in tonalities of blues and grays initiated Picasso's Blue Period. The disciplined use of the single color provides an isolation and sobriety, which matched the Symbolist-inspired mood of the painter's works from this period.

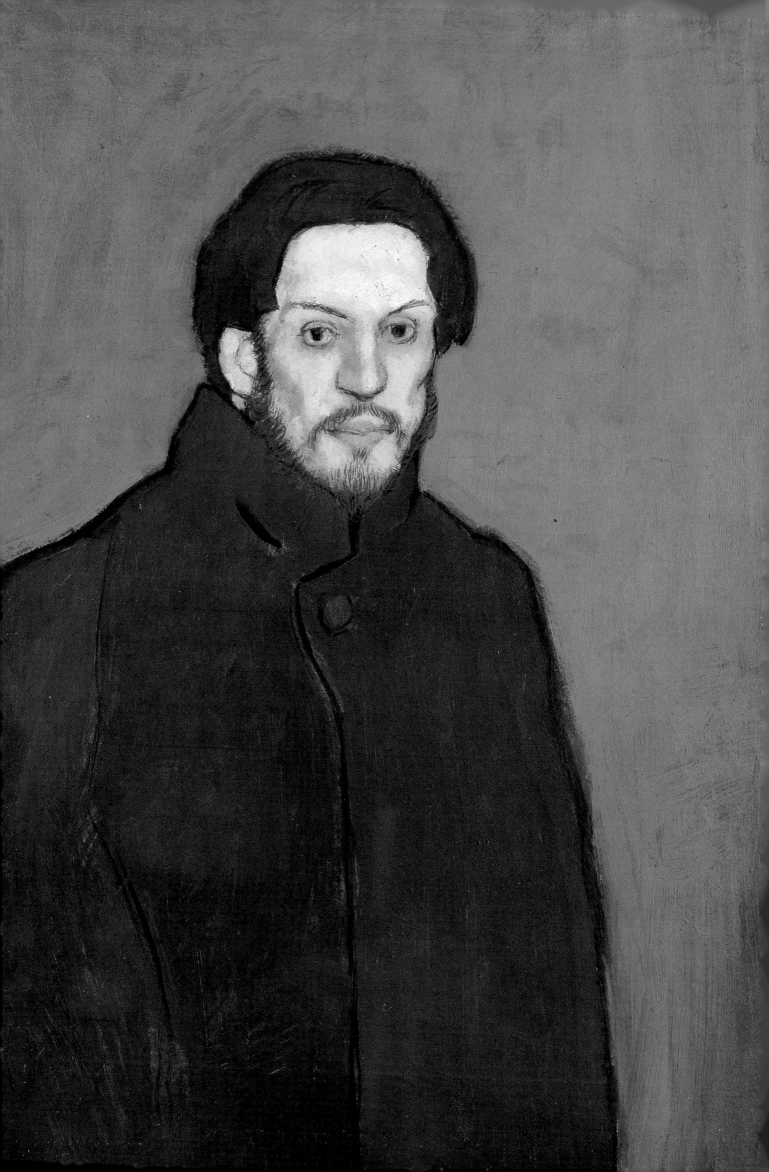

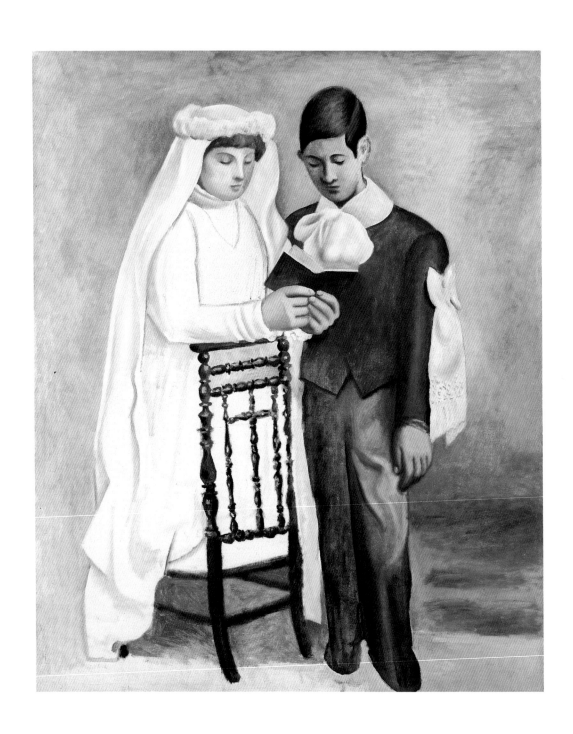

First Communion

1895–1896, oil on canvas; 65³/₈ x 46¹/₂ in. (166 x 118 cm). Museé Picasso, Paris.
This first large canvas painted by Picasso, at age fourteen
to fifteen, is "academic" in its command of the human
form and the technique of oil painting. It was exhibited
alongside the works of fully mature artists in Barcelona.

SPAIN TO FRANCE (1881–1906)

Pablo Ruiz Picasso was the first born of Don José Ruiz y Blasco and Doña María Picasso y Lopez on October 25, 1881, in Málaga, one of the major centers in *el Sur*, that region in Spain's Mediterranean south known as Andalusia. His father was a painter, art teacher, and museum curator who early recognized the genius of his son and provided encouragement and private training.

The precocious child produced his first known oil painting, of a picador, somewhere between the age of eight and nine, inspired by one of the bullfights he attended with his father in Málaga. Trained at home since about 1888, the eleven year old Pablo first enrolled in art school in 1891 in La Coruña, a city in the North of Spain on the Atlantic coastline, where his father had taken a teaching position. Within a year he had moved from drawing ornaments to life drawing, and within two years, at age thirteen, young Picasso mastered the human body on the basis of drawings after plaster casts, a long-held training technique in European academies. At this point his father supposedly recognized fully his son's genius and his own inability to equal it.

By the time Don José accepted a teaching position at the Academy of Fine Arts in Barcelona in 1895, Picasso at age fourteen was already an accomplished artist and he saw limited need for formal training in school. Soon after, in 1897, at age sixteen, the boy quit school and established his own studio. Picasso's self-confidence in his abilities to develop as an artist and to remain independent were personal characteristics of great significance and, by extension, qualities that helped shape the nature of modern art.

Barcelona and Catalonia

In the summer of 1885 the family moved from La Coruña to join Don José at his new position in Barcelona, in the northeast region of Spain known as Catalonia. Young Pablo stopped in Madrid at the

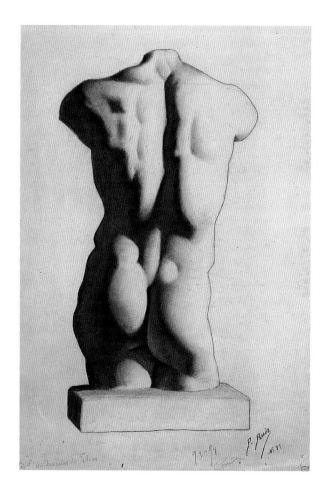

Study of a Torso, after a Plaster Cast

1894–1895, charcoal; 19³/₈ x 12³/₈ in.
(49 x 31.5 cm). Musée Picasso, Paris.

Beneath a life of experimentation lay Picasso's traditional academic training. The artist was in control of his drawing technique by the age of thirteen, with a full understanding of the human figure and of classical beauty.

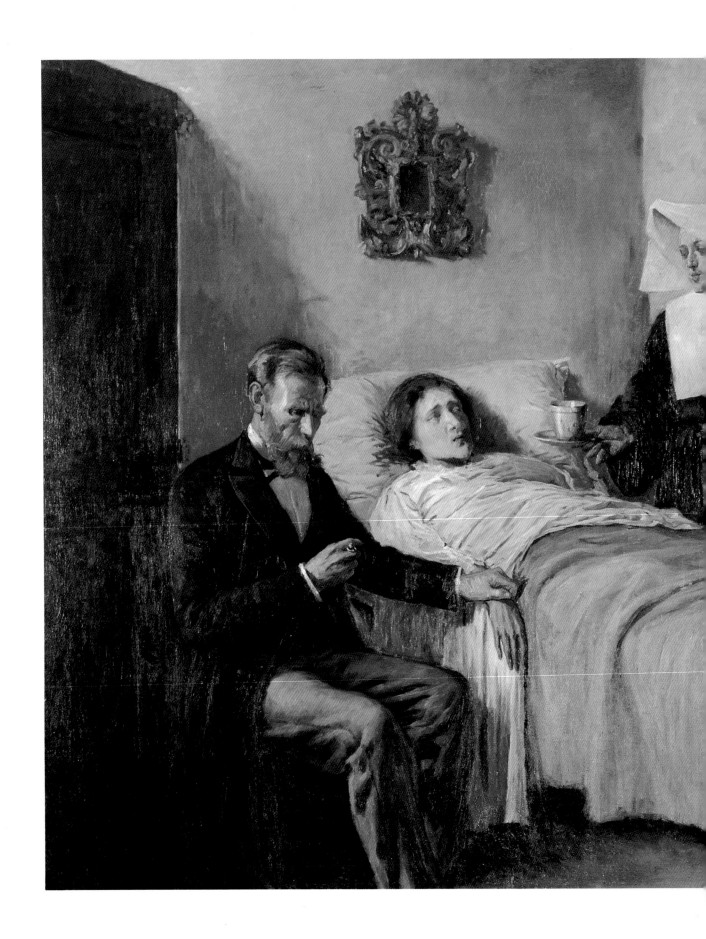

Prado Museum to see the paintings of the great Spanish masters, Diego de Velázquez, Francisco de Zubarán, Francisco José de Goya, and the Greek-born emigré Spaniard, El Greco, for the first time. Their dark tonalities and somber moods may well have influenced his early works. The attenuated forms and mannered gestures of El Greco's paintings were early apparent, as would soon be the tonal qualities of Goya, in Picasso's early oils and later prints. In addition, Velázquez was the master painter Picasso openly returned to later in life, recasting the great Spanish artist in his own image.

That fall he registered at the School of Fine Arts in Barcelona, and completed his first large-scale academic oil painting, *The First Communion*. The painting was exhibited in April 1896, alongside the work of older artists. His second large oil painting, *Science and Charity*, painted in early 1897, showed the same mastery, through a darker palette, won honorable mention in national competition in Madrid, and was received everywhere as equal to the work of fully mature, established artists. This could have been the beginning, at age sixteen, of a full and successful career for Picasso as a talented academic artist. Instead, it represents in its mastery the closing of one cycle and his turn to another phase in life. This restlessness, this turning away toward something new after success, was endemic in Picasso.

What inspired him toward change in this first instance may well have been the intellectual ambiance of Catalonia in general and Barcelona specifically. Catalonia, which has its own spoken language in addition to Spanish, harbored a traditional rebelliousness toward the central government and maintained its autonomy into the Spanish Civil War of the late 1930s, when it was ended by the dictator Franco. In the Catalonia of the late nineteenth century the "modern" movement had found its home, carried by young artists of all persuasions who believed themselves in the vanguard for the establishment of a new order. It was this rebelliousness that corresponded to the personality of the young Picasso, and the languages in which the modern movement clothed

Science and Charity

1897, oil on canvas; 77⅝ x 98¼ in. (197 x 249.5 cm). Museo Picasso, Barcelona.
Picasso's father was reportedly the model for the doctor seen here, representing science, and his sister Lola, the dying woman. Picasso would carry his sense of pathos as well as the dark tonalities from Barcelona to Paris.

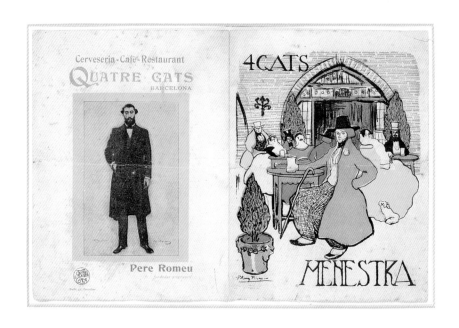

Menu of El Quatre Gats
1899, printed; 8⅝ x 6½ in. (22 x 16.5 cm).
Museo Picasso, Barcelona.
The curvilinear outlines and broad
areas of single, flat color were used
by Art-Nouveau and Symbolist
artists as independent elements
in a style considered "moderne."
The Four Cats café, frequented
by Picasso, was a center for avant-
garde intellectuals and artists.

itself—symbolism, art nouveau, expressionism, and
political anarchy—developed tongues whose rhetoric
persuaded his predisposition.

Part of Picasso's maturation was the motivation
toward independence and the future irrelevance of
exterior instructions. Following a period of separation
from his family in Madrid, the home of Goya, Picasso
returned to Barcelona as if for the first time. He
established his own studio by 1899, and as an eigh-
teen-year-old entered into the social, cultural, and
political life of the modern movement. He frequent-
ed the new café *El Quatre Gats*, a center for artists and
cultural intellectuals. They not only introduced
Picasso to the Art Nouveau- and the Symbolist-influ-
enced poster work of Théophile Steinlen and Henri
de Toulouse-Lautrec, but as advocates of anarchist
politics they encouraged the young artist to argue for
Catalonian separatism and the defense of the down-
trodden. Among these artist intellectuals was Jaime
Sabartés, who would remain a close and lifelong
friend of Picasso's, working later as his secretary.

Taken as a whole, this was Picasso's introduction to
the life of a "bohemian," typical of the cultural avant-
garde at the end of the last century. Picasso sketched
portraits of his assembled friends, designed menus for
the café which embody the Art Nouveau/Symbolist
styles, and had his drawings published in avant-garde
journals in Barcelona. "The Four Cats" first showed
his works in February of 1900. The Symbolist mood
seen in these drawings and designs figured in
Picasso's first major series in Paris, later known as the
Blue and Rose Periods.

Such moods were common as the young Spanish
intellectuals of Barcelona self-consciously defined and
represented themselves as "decadent," with the ablili-
ty to dwell in and represent the "darker," more
expressive dimensions in life. This was an attitude the
French summarized with the phrase *fin-de-siècle*, a so-
called end-of-the century attitude that was associated
in many international art circles with what was meant
to be "modern." In Barcelona it was welded to the
Spanish penchant for shared suffering. As the cursed
or decadent poets (*poète maudit*) of Symbolist fame
believed an unresponsive society caused them to suf-
fer, so these intellectuals and bohemians aligned
themselves with the downtrodden and politically
rebellious who suffered from the same conditions, if
for different reasons. From this mixture of aesthetic
dandyism, *fin-de-siècle* malaise, working-class heroes,
and anarchist agitators, Picasso developed an affinity
for the less fortunate whose record of melancholy he
begins to picture here but will document with author-
ity in Paris.

Sabartés, "Decadent Poet"
1900, charcoal and watercolor on paper;
19 x 12½ in. (48 x 32 cm). Museo Picasso, Barcelona.
Picasso's friend Jaime Sabartés from Barcelona is
portrayed in the dark tones and contour lines of the
Symbolist *poète maudit*, or "decadent poet," lionized by
the cultural moderns at the Four Cats café. Sabartés
became Picasso's trusted secretary years later in France.

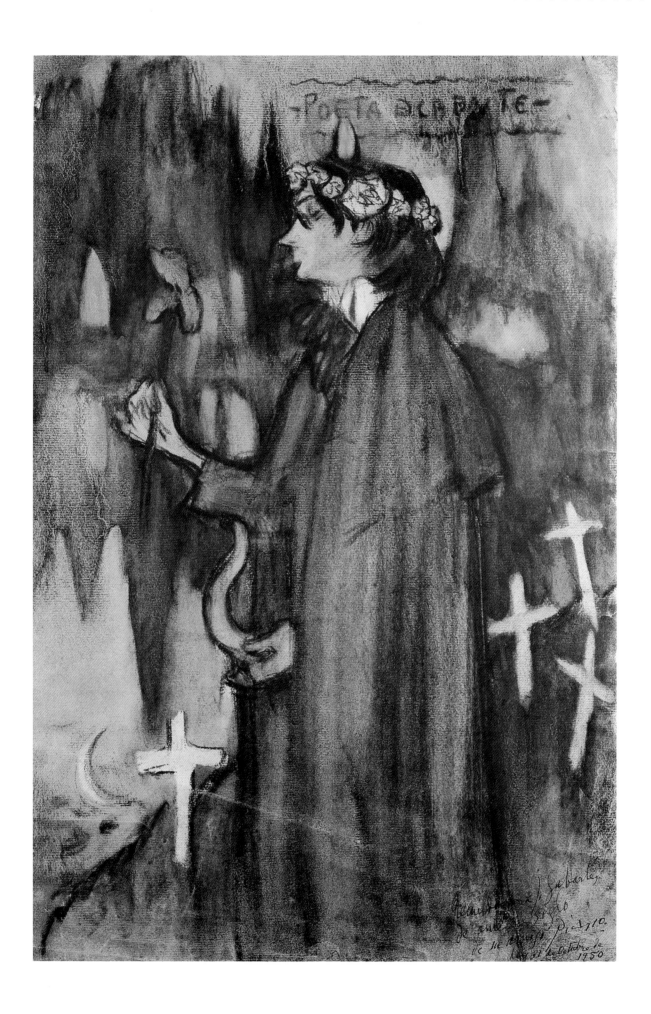

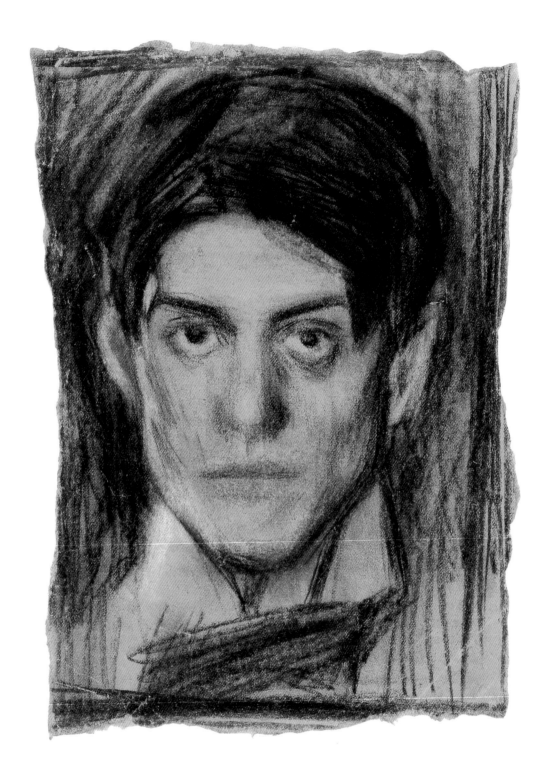

Self-Portrait

1900, charcoal on gray paper, 8⅞ x 6½ in. (22.5 x 16.5 cm). Museo Picasso, Barcelona.
This early self-portrait embodies the haunting melancholy
of the Symbolist and Expressionist traditions in which Picasso
was fully engaged prior to his arrival in France. The mood
in such works would eventually reappear in his Blue Period.

Buoyed by the environment of Barcelona and having a painting selected for exhibition in the 1900 Paris Universal Exposition, Picasso made his first visit to Paris in October of that year for three months just prior his nineteenth birthday. His destination was the colony of Spanish painters in Montmartre, a place he would eventually call home for ten years. The brief visit, guided by his friends who knew the cafés, galleries, and dealers, allowed him to examine firsthand the works of the French Impressionists—particularly Edgar Degas—and their successors, especially the post-Impressionist work of Paul Cézanne and Paul Gauguin as well as the Symbolist works of Henri de Toulouse-Lautrec, Pierre Bonnard, and Édouard Vuillard.

The young painter's first oil paintings made in Paris during that autumn, such as the interior of the dance palace at the "Moulin de la Galette," show a darker reworking of a haunt favored by Parisian artists and the middle class. It has a narrative and compositional style seen in French bohemian artists such as Toulouse-Lautrec, one which turned its back on the lighter, brighter colors favored by the Impressionists and many of the post-Impressionists for a darkness more typical of northern European Expressionists and Symbolists. Even in Barcelona Picasso had apparently known of and admired the artistic milieu in Munich, Germany.

tion from a local picture dealer, Mlle. Berthe Weill, who bought several works and became his first agent two years later; another dealer, a Catalan industrialist in Paris, offered a monthly stipend in exchange for works. This was not only a measure of the early success of the artist but the beginning of his long association with art dealers, who would go on to play major roles in his career.

Picasso generally did not show his works in the large public exhibitions or salons, as was the means for most of the Parisian or European avant-garde, preferring to showcase his work through dealers. Most of the development of Cubism would be carried out through small, private exhibitions, held in commercial art galleries or selected international forums. The early privatism and self-sufficiency of Picasso found here an early match in the commercial art world and helped guarantee the young artist the financial successes and independence he developed and maintained over most of his life.

Paris, as it has done so many times with its artists, reached out to the young Picasso, who decided his future lay in the City of Lights. There was a brief return to Spain, some canvases painted in various styles he had absorbed in Paris, and a general restlessness in the young painter that led him by May of 1901 back to Paris and a permanent settling into his own, shared studio. It was during this shift when he

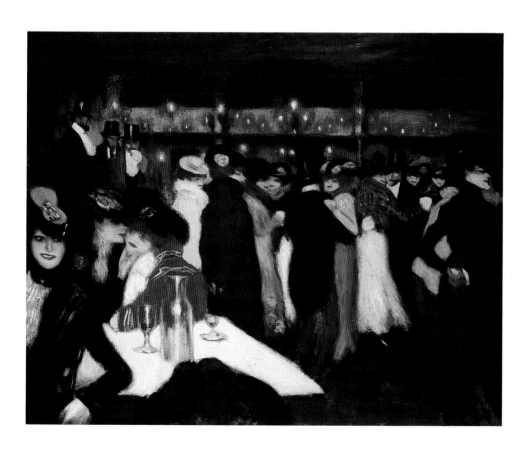

Le Moulin de la Galette

1900, oil on canvas;
34¾ x 45¼ in. (88.2 x 115 cm).
The Solomon R. Guggenheim
Museum, New York.
Picasso's first picture in Paris is of a well-known dance hall, painted also by Renoir and Toulouse-Lautrec, but here it is depicted in the less familiar thick forms and dark tonalities employed by the Symbolists and the Expressionists. The gaiety has an edge to it, in contrast to the Impressionist vision of a bright dance hall.

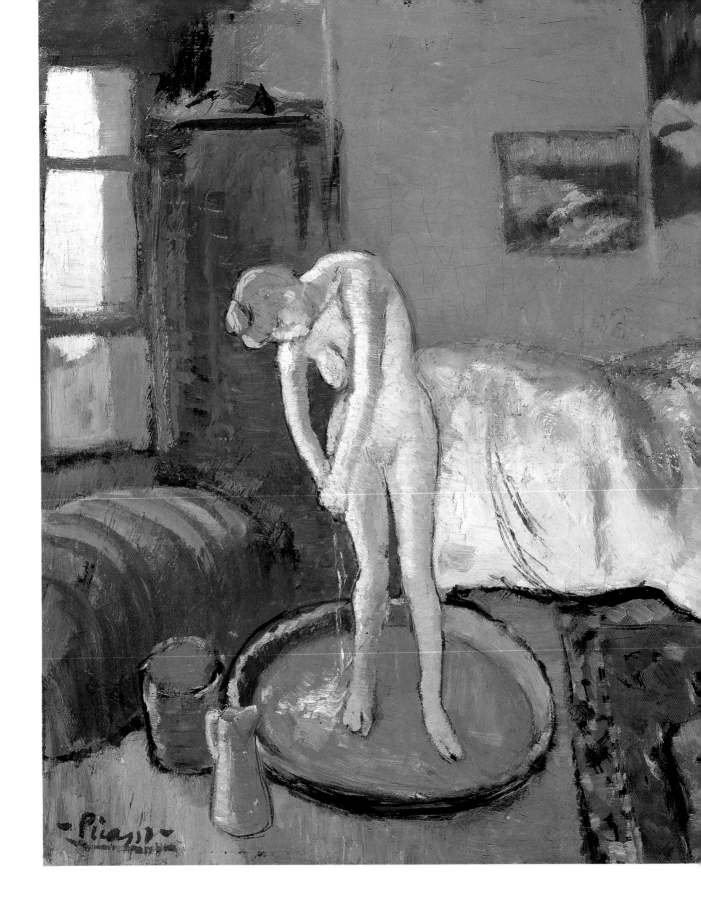

stopped signing his works "P. Ruiz Picasso" and began to use the name of his mother, Picasso.

By June he had arranged his first exhibition in Paris at the Galeries Vollard, where his self-portrait, *Yo Picasso*, was shown, among other works, fifteen of which sold. This dynamic self-portrait of dark background and sketchy brushwork, derived from his Symbolist work, combined with brighter colors in a style his later friend and rival in Paris, Henri Matisse, explored within the French Expressionist movement known as *Les Fauves* ("The Wild Beasts"). There will ever after be an "expressionist" aspect to Picasso's aesthetic.

The Blue Period

By the fall of 1901 Picasso's canvases began to be dominated by blue and gray tonalities, and Picasso established his first recognized phase of art, known as the Blue Period, which ran from late 1901 until the middle of 1904. This is the first time Picasso placed his own distinct stamp upon art, working first and predominantly in blue and then changing to rose colors somewhere between 1904 and early 1905.

Many explanations have been offered for his first and exclusive dedication to blue. It was a natural extension of the dark tonalities found in the Symbolist-inspired paintings of the European avant-garde and particularly in Barcelona, now personalized to an obsessive degree. An obvious dimension of somber mystery emerges out of the dark blues and grays, lending a pervasive if unexplainable mood of melancholy. Many have linked this melancholy to Picasso's Spanish heritage, where the contemplation of death and suffering provided touchstones for generations within Spanish culture, as seen in bullfights and church rituals, as well as to a *fin-de-siècle* nostalgia for a passing millennium.

Others have offered as explanation the suicide death of Picasso's friend Carlos Casagemas, with whom he first traveled to Paris in 1900 and who killed himself in a Paris café over a failed love affair. Picasso had sketched his dead friend several times and it is his portrait that appears on the head of the male figure in

The Blue Room
1901, oil on canvas; 20 x 24½ in. (50.8 x 62 cm).
The Phillips Collection, Washington, D.C.
The blue and grays of the walls and bedding make this a transitional work to Picasso's Blue Period. The bathing nude is typical of Impressionism, but unlike that school of art the room and her isolation seem more the subject of the painting.

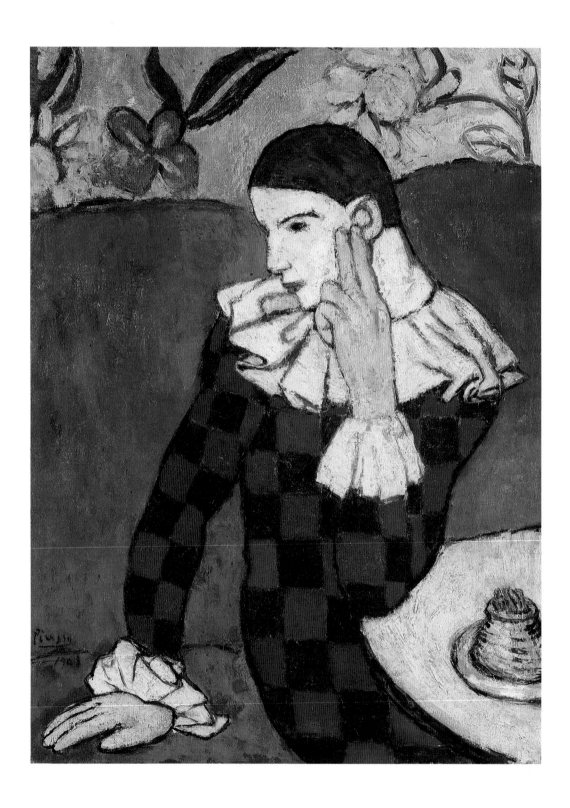

Harlequin

1901, oil on canvas; 32⅝ x 24⅛ in. (82.7 x 61.2 cm). Gift of Mr. and
Mrs. John L. Loeb, 1960, The Metropolitan Museum of Art, New York.
Harlequin is a comic pantomime figure considered part
rogue, part buffoon. Picasso saw something of himself in
the character and portrayed it frequently as a surrogate self-
portrait, later depicting his young son as the same figure.

Picasso's largest allegorical painting from this period, *La Vie*, which he painted on a return to their home city of Barcelona in 1903.

As fetching as this biographical explanation may be, it is difficult to justify several years of work as the result of a single event. Nor does his friend's death take into account the idea that Picasso's consistent and self-imposed use of limited colors is typical of a powerful will, which consistently restricted avenues of artistic production in order to explore a theme or idea more completely. Setting purposeful limits was a procedure Picasso followed throughout his career. Perhaps the concept of "genius" unfairly limits judgments by excluding the issue of discipline in favor of overly romanticizing the wild and random aspects. Yet the nature of Picasso's willpower should be easily and equally visible in the consistently direct stare that actively seeks out the world in each of his self-portraits.

During the Blue Period Picasso introduced a cast of characters and themes that remained throughout his life, and which, one suspects, took on symbolic meanings of a personal nature. The harlequin became a central character in Picasso's cast, a figure taken from the pantomime theater of the streets and working class, and whose roguish character Picasso seemed particularly to identify with. The theater attracted Picasso in Barcelona, along with other members of the bohemian culture, and he was infatuated with it all his life. On more than one occasion Picasso likened aspects of artistic creativity to play and playing, by which he likely meant references to both the childlike state of mind, much celebrated by Expressionists and, later, the Surrealists, and theatrical masking as a metaphor for freedom. The mask as well as direct references to the theater remain stitched within Picasso's work and conceptions of art.

The theme of the female principle made its debut in the Blue Period. Women and their representation played a major role in Picasso's art and life with a wide range of interpretation—a pervasive archetype from child innocent and private muse to sensuous creature; from motherhood to victim of rape, women became more an archetypal principle constructed from a male viewpoint than a specific identify. Maternity was bound within this early theme, and so was pornography.

Finally, and most notable, from this period, all painted characters seem a part of some generalized lower or out-class, possessing an overriding concern for the themes of misery and sadness brought on by physical poverty and resulting in some form of depression. Picasso's sympathy for outcasts may be traced back to Barcelona, yet there is something more personal here, beyond an alignment with avant-garde ideas. Even artists and critics associated with the Symbolists found his works starkly sad, rendering so well "the beauty of the horrible."

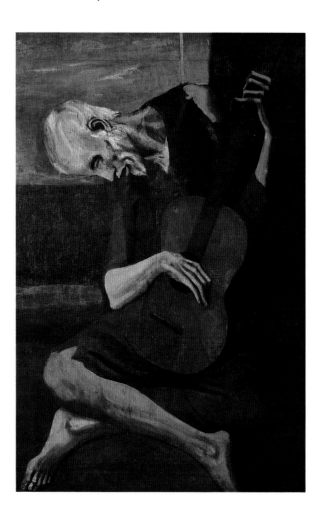

The Old Guitarist

1903, oil on canvas; 47¾ x 32½ in. (121.3 x 82.5 cm).

Helen Birch Bartlett Memorial Collection, The Art Institute of Chicago, Chicago.

Picasso's Blue Period dealt with the isolation of the aged and social outcasts. The attenuated proportions suggest the influence of El Greco, an artist the Spanish Symbolists restored to public attention and one who seems to have particularly affected Picasso.

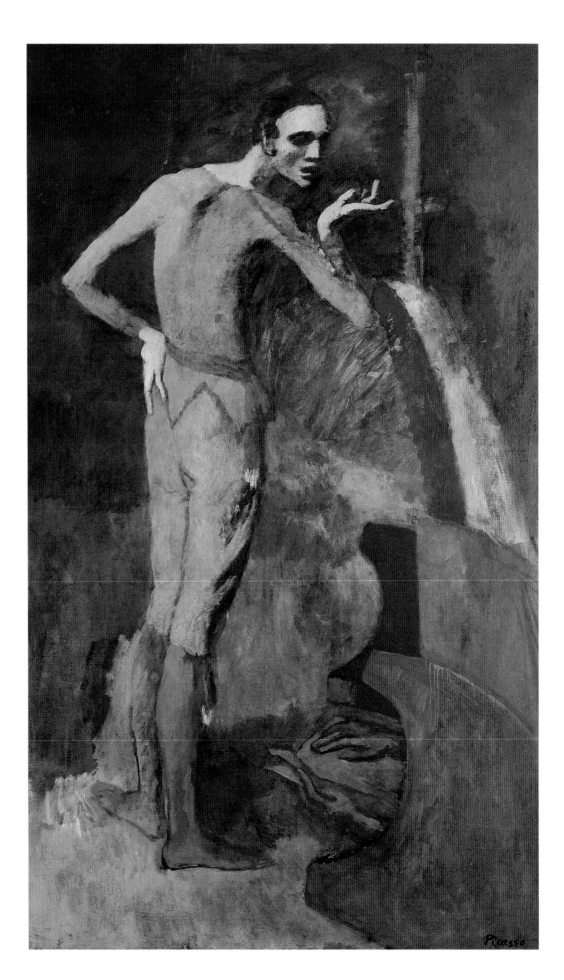

The Actor

1904–1905,
oil on canvas;
76³/₈ x 44¹/₈ in.
(194 x 112 cm). Gift of
Thelma Chrysler Foy,
The Metropolitan Museum
of Art, New York.
The colors in this
work show Picasso
in transition be-
tween his Blue and
Rose Periods. The
emphasis on hand
gestures and head,
and the use of an
elongated, curvilinear
body, are typical
of his early works.

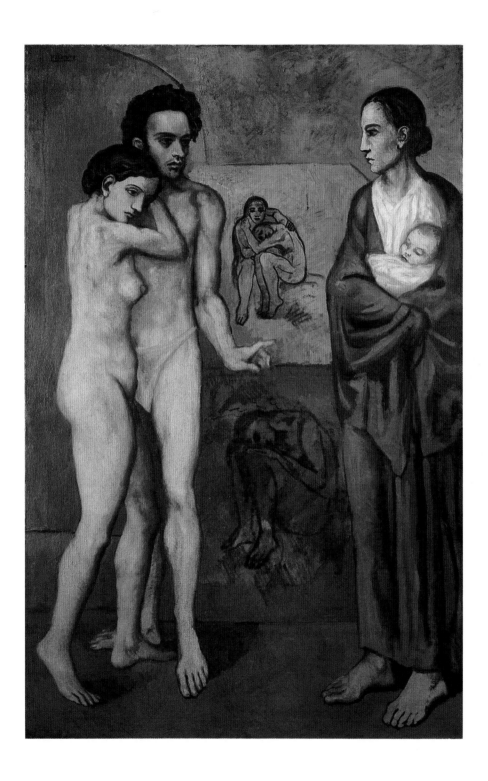

La Vie

1903, oil on canvas; 77⅜ x 50⅝ in. (196.5 x 128.5 cm). Gift of the Hanna Fund, The Cleveland Museum of Art, Cleveland.
Picasso's largest canvas to date, the male figure here closely resembles his friend
Carlos Casagemas, who had recently committed suicide in a Paris café over a lost
love. In the original drawings the male figure was a self-portrait, yet it remains
a commentary on the nature of life from a Symbolist perspective.

The Rose Period

The last of Picasso's Blue paintings dated from the spring and summer of 1904 and coincided with the end of his traveling between Paris and Barcelona. From this point Picasso remained in France, though there always will be arguments as to which nation best shared his soul. He settled into a rundown studio building at 13 rue Ravignan in Montmartre, known by its slang name *Bateau Lavoir*, or "Laundry Barge," due to its size, condition, and awkwardness. Here Picasso became the center of another group of bohemians, which included but moved beyond his Spanish colleagues. Now firmly part of the Parisian scene he began his second series, dubbed his Rose Period, which he first exhibited as a group in February of 1905.

He continued his use of monumental figures set against monochromatic backgrounds but now used varying tones of rose color. The mood of extreme sadness and melancholy lessened but his figures remained introspective and contemplative. Characters from the lower classes were more often superseded by performers and circus figures, and this period is also often referred to as his Circus Period. The figures of "Pierrot" and the harlequin from stage and street theater pantomime had been introduced in Barcelona. Now the harlequin, the slightly roguish character with whom Picasso identified and employed frequently as a self-portrait, took on greater importance, as did the "Saltimbanques."

The harlequin is usually identifiable by a diamond pattern in his costume, while the saltimbanque is more generalized through the French word for buffoon or charlatan—a variation of the circus clown. But the two seem to run together in his circus paintings, combined with acrobats, jesters, and actors. None of these depict the joy and gaiety normally associated with clowns and circuses. The circus people were no longer solitary figures but surrounded by families and friends from the Cirque Médrano, which was performed at the foot of Montmartre near the Bateau Lavoir, a place Picasso and his friends regularly attended. Despite their social context the figures also retained their distance and an air of mystery that held personal meaning for Picasso.

The bohemian artists in general and Picasso in particular associated their existence as cultural outcasts with the lives of the circus performers in a part of Paris that was a more vital and international version of his Barcelona. Montmartre, located on the hill on the right bank of the Seine River, which is the highest point of the city and capped by the Church of the Sacré-Coeur (Sacred Heart), was already considered the center of cabaret entertainment and bohemian life with its spectacles of circuses, night cafés, dance halls, and bordellos. Its denizens and habitués had been the subject of numerous artists throughout the 1880s and 1890s. Among them was Georges Braque, soon to be Picasso's confident in the development of Cubism, who located his studio here, while Maurice Utrillo, adopted son of a Barcelona artist, painted its bistros and apartments unstintingly. Montmartre at this time became a metaphor for the bohemian life-style of the cultural avant-garde, defined as a group of people who inhabited by choice the fringes of society.

"Les Fauves"

Paris was rocked by the so-called scandal of the "Wild Beasts" (*Les Fauves*) in October of 1905. Led by Henri Matisse, these painters used pure color in seemingly arbitrary fashion to decimate the academic concept of form in art and momentarily established French Expressionism as the leading art movement. Matisse went on to become one of the great masters of twentieth-century art. At this point he was more scandal than success but he did attract the attention of the Steins, first Leo and then his famous sister Gertrude, newly arrived in Paris from the United States, who began buying works by the Fauves. At the same time they began to buy Picasso's works, bringing Picasso and Matisse into the orbit of their weekly salons, which were attended by most of the young, creative intellectuals in Paris. It was here one Saturday night in the autumn of 1905 that the two painters who were to form two of the major dispositions for the art of the twentieth century first met.

At the same time Picasso befriended a group of young poets and writers who became leading lights in contemporary Parisian culture, including Max Jacob, Guillaume Apollinaire, Alfred Jarry, Pierre Reverdy, André Salmon, and Maurice Raynal. In addition, his seven-year relationship with Fernande Olivier, another resident of the Bateau Lavoir, had begun by the autumn of 1904. She was to be the first of several significant women in his long life, all of whom were well recorded in his art. Not only do we sense a new warmth in the Rose Period, which many attribute to his relation with Fernande, but the family groupings have been interpreted as analogous to the burgeoning circle of Picasso's friends, referred to as *Las Bande Picasso*. Virtually all the Rose Period paintings were bought by the art dealer Ambroise Vollard, with whom he had exhibited in 1901. True to his personality, however, just as recognition and success greeted him, Picasso turned again.

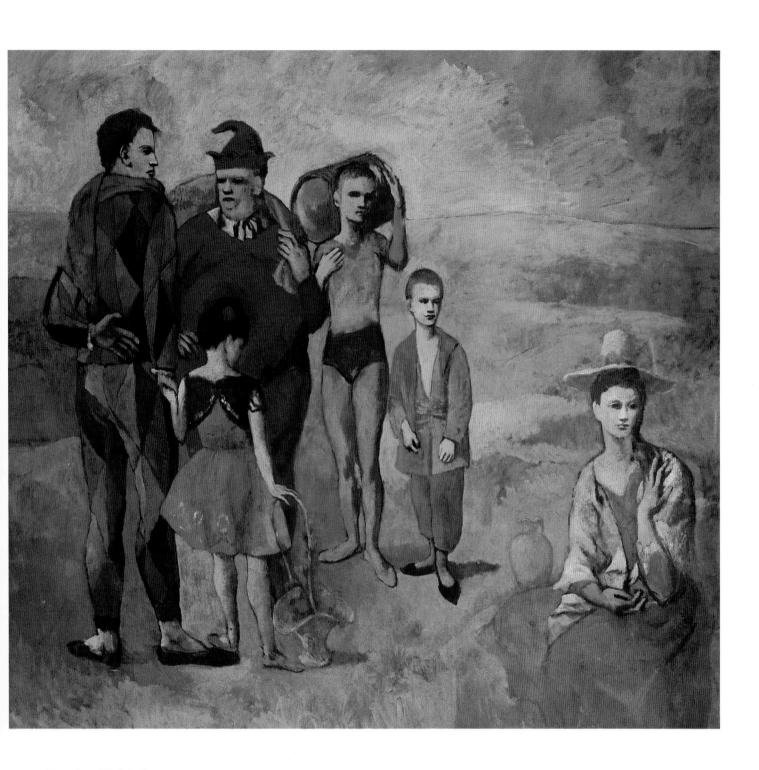

Family of Saltimbanques
1905, oil on canvas; 83¾ x 90⅜ in. (212.8 x 229.6 cm).
Chester Dale Collection, National Gallery of Art, Washington, D.C.
The importance for Picasso of the circus performers
of Montmartre in Paris is attested to by the size of
this canvas, at 7 square feet (2.3 meters) his largest ever.
Memories of this painting inspired the German lyric
poet Rainer Maria Rilke, who had lived with it in 1915.

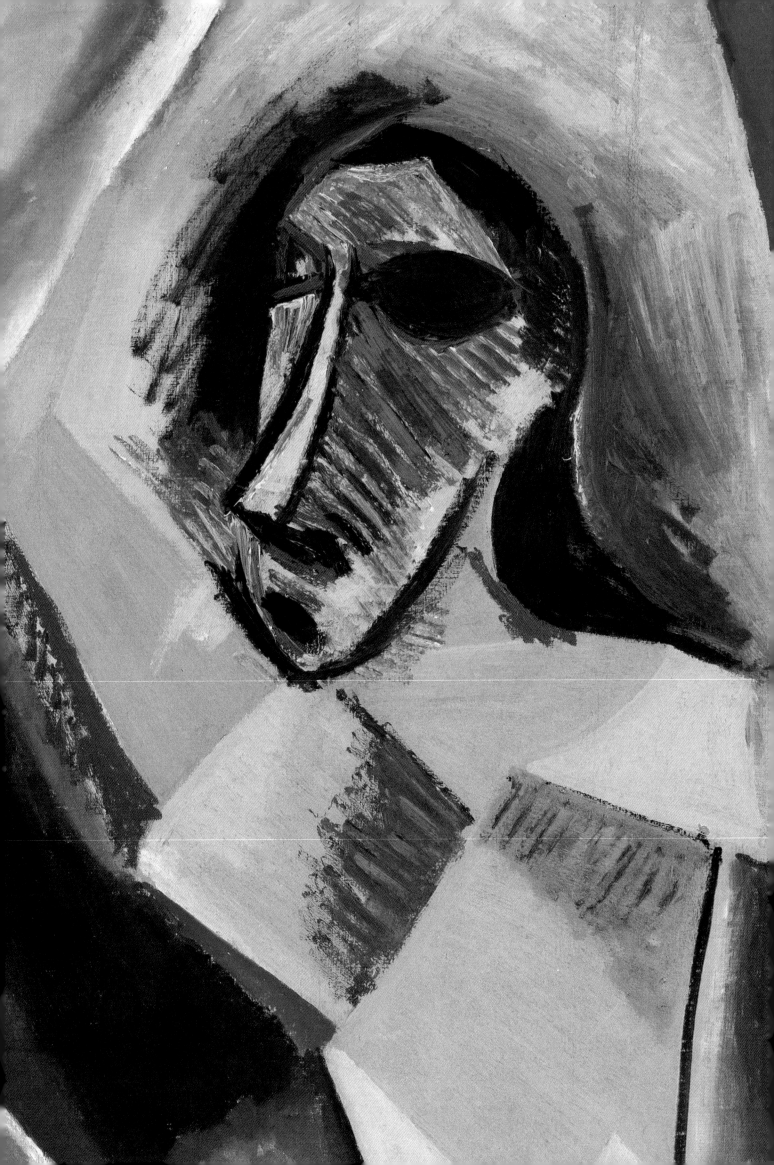

Les Demoiselles d'Avignon, 1906-1909

Two major influences appeared now in fairly quick order in Picasso's works—that of the post-Impressionist painter Paul Cézanne and the impact of what generally but carefully can be called "primitive" art. In *Boy Leading a Horse* from early 1906 the ambiguity of the setting remains typical but here grays and browns replace roses and blues. More important, the dark body outlines of horse and boy lay the stress on the physicality of form. It is no longer attenuated or taken for granted, as for instance a Symbolist exercise in expression and depression. This painting and a remarkable series of works throughout 1906 present large, mostly flesh-toned and brown figures, whose linear enforced contours and segmentation of body parts invoke the late nudes in Paul Cézanne's remarkable series of paintings of bathers.

Paul Cézanne was a recluse and not well known to the general public, but he was much admired among the Parisian avant-garde following his 1895 exhibition with Vollard as well as through memorial exhibitions surrounding his death after 1906. Cézanne developed new aproaches to depicting physical form that he felt reflected something more solid than Impressionist flickerings of light or the Symbolists' decorative use of large planes of flat color. Cézanne made it clear he was after a fundamental restructuring of the "real" world, understood more through the moving eye and arm of the painter than seen through a creation of a painted window looking into a falsely unified space with discrete objects.

Such a concentration on basic structure was at the heart of French classicism but now updated in a way no academic painter would recognize or accept because it included a modern awareness of the actual process and means of painting. This was realism of quite a different dimension and Cézanne's experiments, while perhaps not fully comprehended, sent a number of young Parisian painters scrambling in new directions, including Georges Braque, whose life and

Les Demoiselles d'Avignon

detail; 1907. Acquired through the Lillie P. Bliss Bequest,
The Museum of Modern Art, New York.

The influence of African sculpture is most clearly seen in the complex mask replacing the facial features in this celebrated painting. But the lessons of Cézanne's series of bathers is also apparent in the overall composition and in stylistic experiments such as the bending of the shoulder into space through the juxtaposition of planes of color.

work intersects with Picasso's in 1907. That said, the large, bulky figures and simplified faces that Picasso began to develop around 1906 were also something more than Cézanne's new body types; something more "primitive."

Sometime in the spring of 1906 Picasso visited an exhibition at the Louvre of ancient Spanish sculpture recently excavated not far from his Andalusian birthplace. Better known as "Iberian" sculpture, after the early name of the peninsula, these works were created by Iberian peoples who were believed to have migrated from Africa during the Neolithic period; their sculptures portrayed simplified volumes and schematic features. Picasso so loved them he bought two in March 1907, even though they had been stolen from the Louvre by Apollinaire's secretary. To this he added a "revelation" he had had in front of African sculpture, which he supposedly first visited at the Trocadéro ethnographic museum in May or June of 1907. Such so-called primitive art intersected and reshaped Picasso's work, culminating in what is now considered one of the masterworks of the twentieth century, *Les Demoiselles d'Avignon*.

The first major indication of this change came in his *Portrait of Gertrude Stein*, a writer and one of his major patrons, which he began in the winter of 1905–06. After some eighty sittings, as recorded by Stein, Picasso painted out the face in frustration and left with Fernande Olivier for the quietude of a small mountain village in Spain. Upon his return to Paris, after executing a number of paintings that summer, he was able to repaint the face of Stein without seeing her again. The result was something almost frightening to his contemporaries. Her head was now "Iberian," a mask of simplified and powerful planes which matched the physical and intellectual power of the modernist author. Stein was reportedly well satisfied and kept the portrait nearby all her life. Typically Picasso did not seem to fully understand what he had done but knew the painting pointed to a direction he wanted to pursue.

Works followed which experimented with the same concepts, such as his *Self-Portrait with Palette* in the autumn of 1906. But these too were as preludes to the greater experiment of *Les Demoiselles d'Avignon*, begun in late April to May of 1907, near the time of his first visit to the ethnographic museum in Paris and the exposure to African art.

Matisse and the Fauves had long been exploring and even collecting ethnographic art, and a number of paintings by Matisse had made their impact obvious. There was a new simplification of forms and rude

power that culminated in Matisse's large and revolutionary picture *Bonheur de vivre* (frequently translated as "The Joy of Life"), exhibited in the autumn of 1906. The subject matter—a pastoral celebration of life in nature—its brilliant flat colors and the simplified forms surrounded by thick, rhythmic contour lines, displayed not only a raw power but a new elegance that marked the beginning of Matisse's personal integration of the primitive. It was immediately bought and displayed by the Steins, and there is little doubt it provided a challenge Picasso would not allow to go unanswered. A similar translation of the primitive was at hand.

Les Demoiselles d'Avignon was so large, about 8 feet square (2.4 meters square), it required a new stretcher and type of canvas for the painter. Although it is debated whether or not the work was ever finished by its final state as of July 1907, its many studies and repaintings establish it as an arena in which Picasso recorded the influences of his native Iberian sculpture reworked through the influence of African sculpture, an influence Picasso would later deny. Its title, given by André Salmon, originated from a private joke by Picasso concerning a notorious brothel on Avignon Street in Barcelona, and early drawings showed a sailor, now removed, in the midst of the women. The five women portrayed a progression in the artist's thinking, moving from the masklike face derived from the Iberian sculpture, seen in the two middle figures, to the development of literal masks, as in the figure on the far left who holds back the curtain to the two figures on the right.

The same trajectory shows a rethinking of the terms of the human body, from a simplified naturalism in the center figures to an increased sense of its fragmentation into angular forms, each of which appeared to have an independent existence. Such disjunction of body parts challenged the standards by which the human body had been constructed for the last five hundred years in the Western tradition of painting. In synchrony, the background elements of draperies and wall were fragmented, aligned with the figural handling. This confounded the typical formal separation of a figure standing against a distinct space for something more integrated, if confusing.

There is every indication that Picasso, once again, did not fully understand what had developed here. He did not show the work publicly until 1916, although most of the young Parisian avant-garde trooped through his studio to see and be confused by it. He spent the next several months of 1907 and 1908 working out the implications seen in *Les Demoiselles*, a time often referred to as his Negro Period, alluding to the African influence. The term is misleading, however, since it implies only one source for Picasso's work when the situation was far more complex. Whether one considers the work Cézannesque, Iberian, or African; whether it be an opening, a summary, or an on-going meditation, it surely records a major turning point for the artist and a point after which the history of art will be changed.

In retrospect, *Les Demoiselles d'Avignon* has long been considered the opening salvo to what many believe the most important art movement of the twentieth century, the one with which Picasso's name is most associated: Cubism.

Les Demoiselles d'Avignon
1907, oil on canvas; 96 x 92 in. (243.9 x 233.7 cm).
Acquired through the Lillie P. Bliss Bequest, The Museum of Modern Art, New York.
Few works can be credited with altering the course of art history.
The so-called death of Renaissance painting dates from this painting,
even though the concept was challenged earlier on many other artistic
fronts across Europe. Considered by many to be the beginning of
Cubism, this work is a sketchbook of developing ideas and influences.

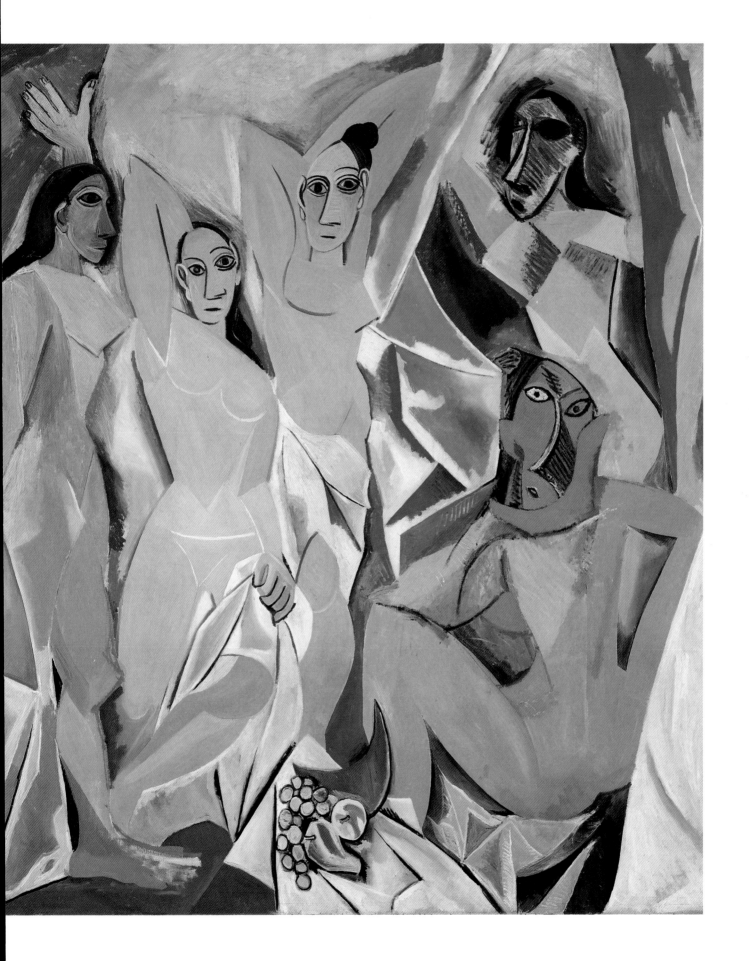

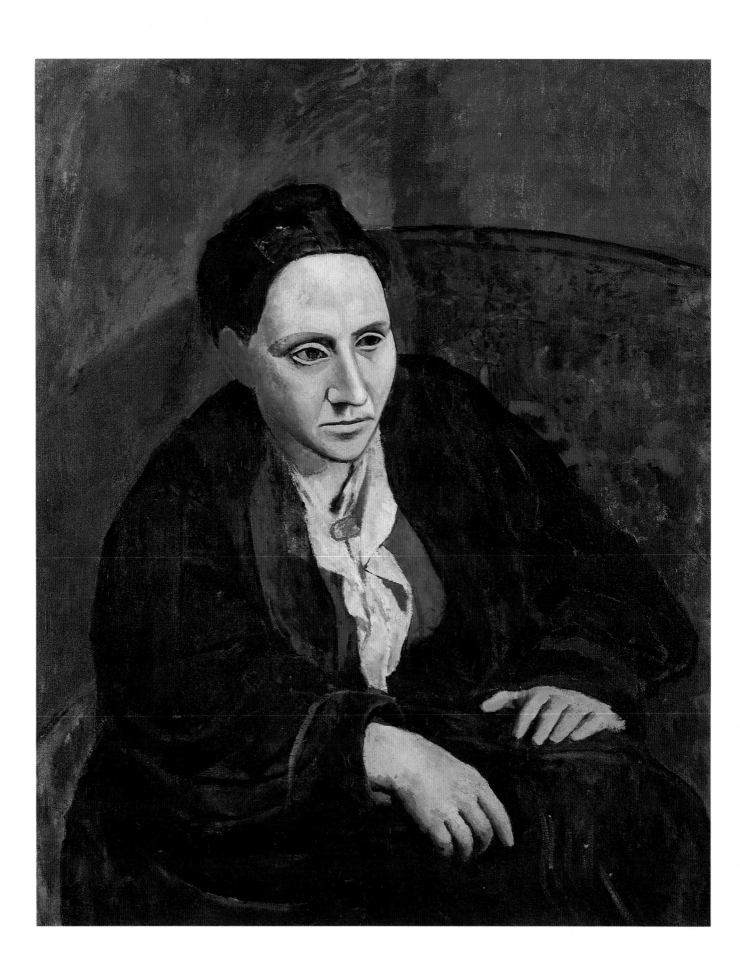

Self-Portrait with a Palette

1906, oil on canvas; 36¼ x 28¾ in. (92 x 73 cm). A. E. Gallatin Collection, The Philadelphia Museum of Art, Philadelphia.

The simplified, severe mask used for his own face shows Picasso's interest in the pre-Roman sculptures of his Spanish homeland he had seen in the Louvre. The body has been "primitivized" through its simplification into crude, bulky shapes.

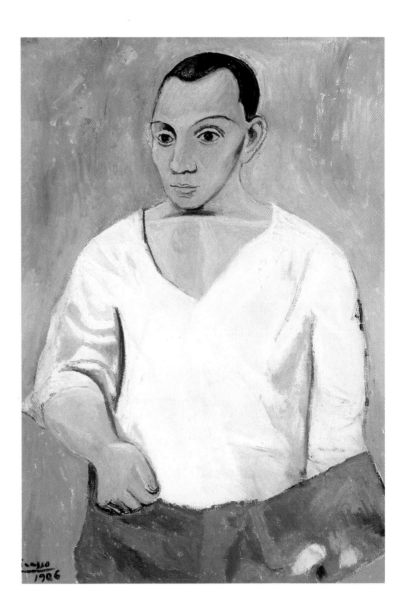

Portrait of Gertrude Stein

1905–1906, oil on canvas; 39¼ x 32 in. (99.6 x 81.3 cm).
Bequest of Gertrude Stein, The Metropolitan Museum of Art, New York.
Gertrude Stein was a major patron of Picasso and this is one of the few portraits the painter made directly from the model. The beginning of a new style can be seen in the masklike face and the fusion between the figure and background planes.

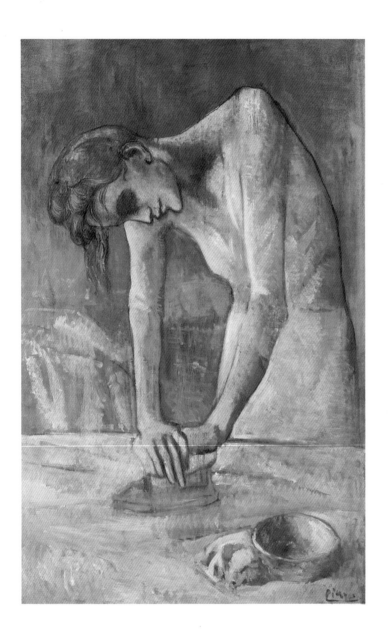

Woman Ironing
1904, oil on canvas;
45³/₄ x 28³/₄ in. (116.2 x 73 cm).
Gift of Justin K. Thannhauser,
The Solomon R. Guggenheim
Museum, New York.

This subject was a favorite of
French painter Edgar Degas,
but is rendered here less as an
Impressionist slice of life and
more as a figure of pathos.
It is partly a testament to the
reality of the hardships young
women faced while seeking a
better life in the "City of Lights."

Meditation (Contemplation)
1904, watercolor and pen; 13⁵/₈ x 10¹/₈ in. (34.6 x 25.7 cm).
The Museum of Modern Art, New York.
The artist contemplates a woman as a traditional,
allegorical representation but the muse is real.
Fernande Olivier, Picasso's lover for the next
seven years, is the first of a series of significant
women in his life who regularly appear in his works.

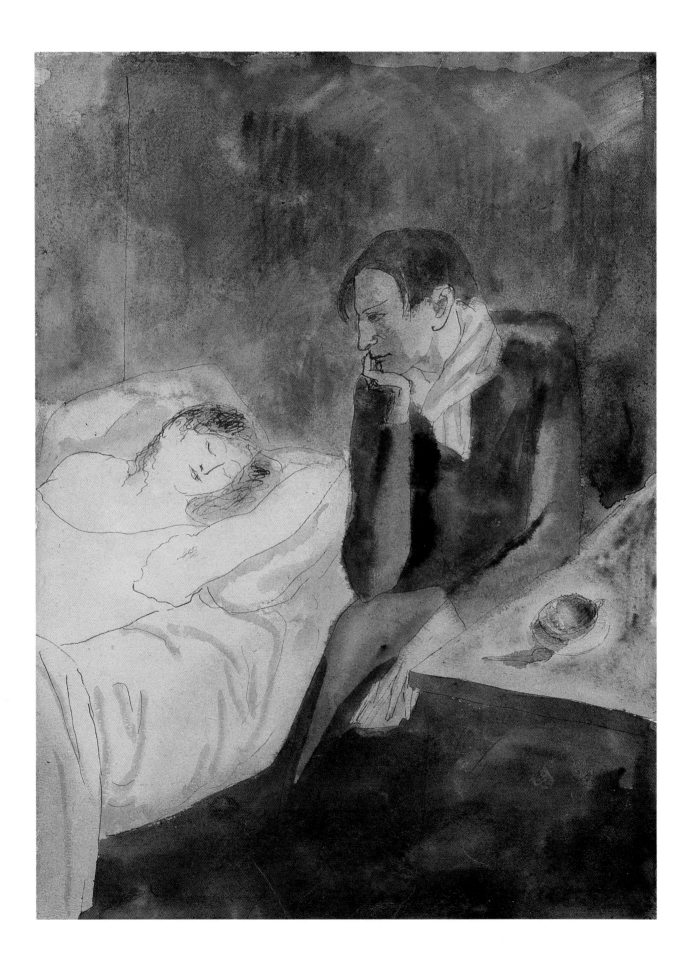

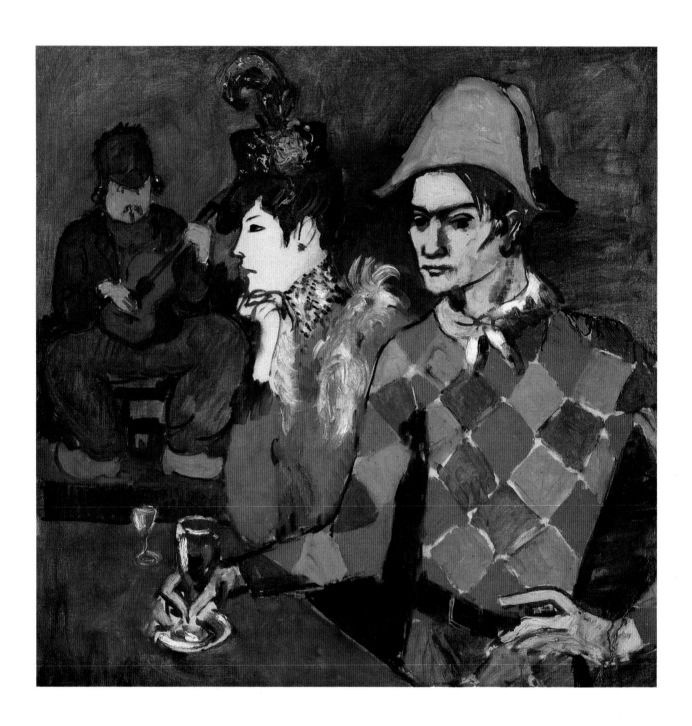

At the Lapin Agile

1905, oil on canvas; 39 x 39½ in. (99 x 100.3 cm). The Walter H. and Leonore Annenberg Collection, Partial
Gift of Walter H. and Leonore Annenberg, 1992. The Metropolitan Museum of Art, New York.
This is the first painting where Picasso clearly painted his own likeness
into the role of the Harlequin figure, the gaudy clothing in contrast to
the melancholy psychology of the young Picasso. This painting was nailed
to the wall of the bar, "The Agile Rabbit," taking its place among many
others swapped by artists for drinks with its owner, Fredé.

The Frugal Repast

1904; etching, 18³/₁₆ x 14¹³/₁₆ in. (46.5 x 37.6 cm).
Gift of Abby Aldrich Rockefeller, The Museum of Modern Art, New York.
The starkness of the characters and style of the
Blue Period translated easily and perhaps gained in
expressivity in the medium of printmaking. This was
Picasso's second effort in etching, a technique he explored
extensively in his more expressive period of the 1930s.

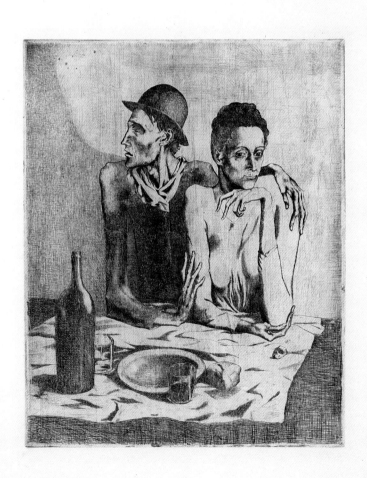

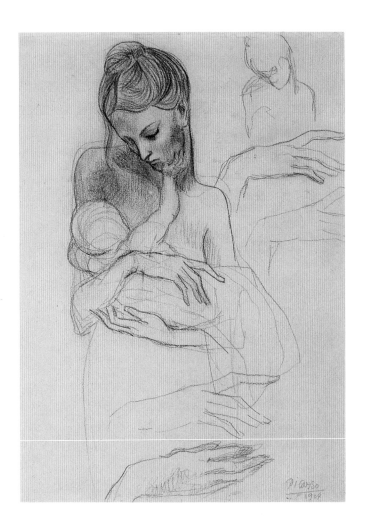

Mother and Child

1904, black crayon on cream-colored paper;
13½ x 10½ in. (34. 2 x 26.6 cm).
Bequest of Meta and Paul J. Sachs,
Fogg Art Museum, Harvard University,
Cambridge, Massachusetts.

The woman is the model for
many works from this period,
but only her name, Madeleine, is
known. The theme of *maternité*
joins the theme of the Madonna
and Child to everyday life.

Lady with a Fan

1905, oil on canvas; 39⅜ x 32 in. (110 x 81.3 cm).
Gift of the W. Averell Harriman Foundation in memory of
Marie N. Harriman, The National Gallery of Art, Washington, D.C.

The painting is part of a group in late 1905 in which
the moods of detachment and austerity seem to
increase as they transit from blue into rose colorations.

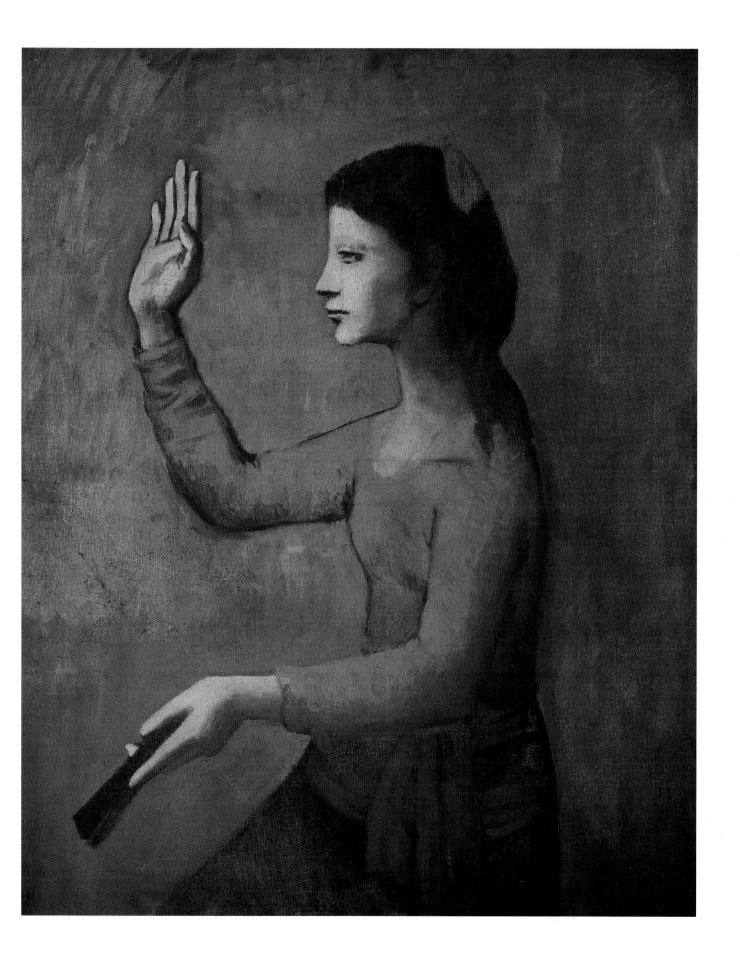

Boy
Leading a Horse

1906, oil on canvas;
86¾ x 51½ in.
(220.3 x 130.6 cm).
Gift of William S. Paley,
the donor retaining life
interest, The Museum of
Modern Art, New York.

In the development
of Picasso's work, rose
tonalities gave way
to grays and browns.
Physical form was
no longer taken for
granted, and is here
quite different from
the sketchy, attenuated,
and unfinished qualities
of his earlier works.
The influence of
French painter Paul
Cézanne's figures is seen
in the thick contours.

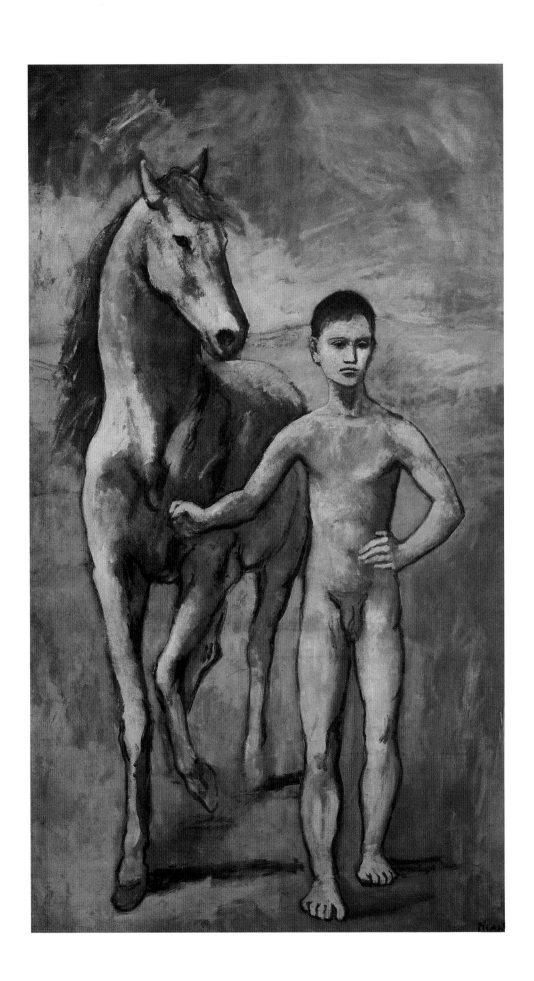

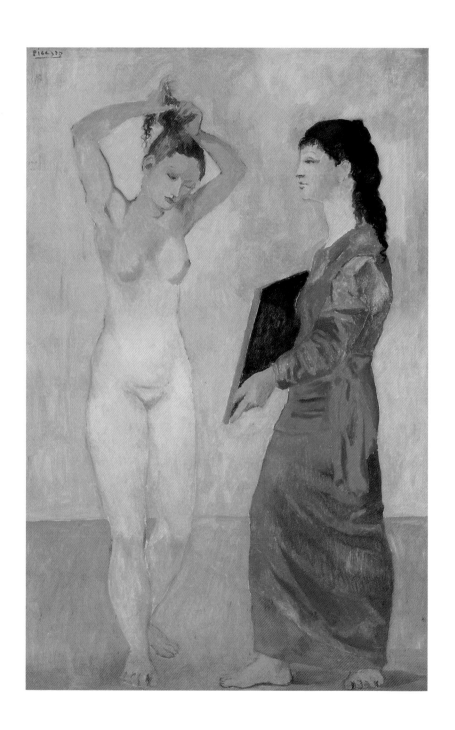

La Toilette

1906, oil on canvas;
59¹/₂ x 39 in. (151 x 99 cm).
Fellows for Life Fund, Albright-
Knox Art Gallery, Buffalo.
The rose tonalities
remain but Picasso's
figures began to take
on a greater sense of
dimension and weight,
as seen here. Their
sense of size and
quietude made them
appear "classical" by
modern standards, a
spirit likely derived
from the artist's new
interest in sculptural
forms, begun late in 1905.

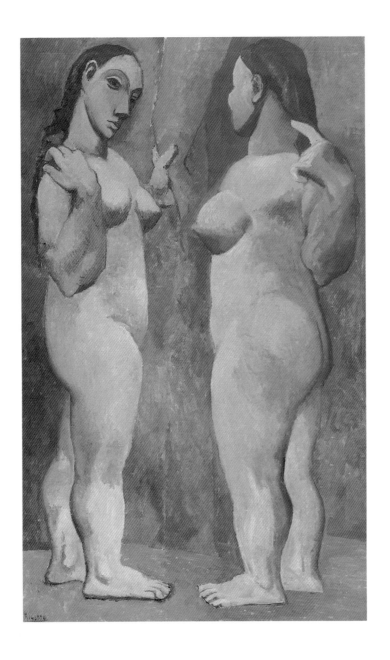

Two Nudes

1906, oil on canvas; 59⁵/₈ x 36⁵/₈ in.
(151.3 x 93 cm). Gift of G. David
Thompson in honor of Alfred H. Barr, Jr.,
The Museum of Modern Art, New York.
As part of a series of large-
bodied female nudes, these
figures show Picasso working
his way through his exposure
to Iberian sculpture with a new
simplicity of form. The figures
have the solidity of sculpture.

Self-Portrait

1907, oil on canvas; 19³/₄ x 18¹/₈ in.
(50 x 46 cm). National Gallery, Prague.
Picasso likely enjoyed the
correlation between the
large, staring eyes of ethno-
graphic masks and his own
well-known intensity. Leo
Stein half-jokingly refused
to let Picasso read his books
for fear of the painter burning
holes in them with his stare.

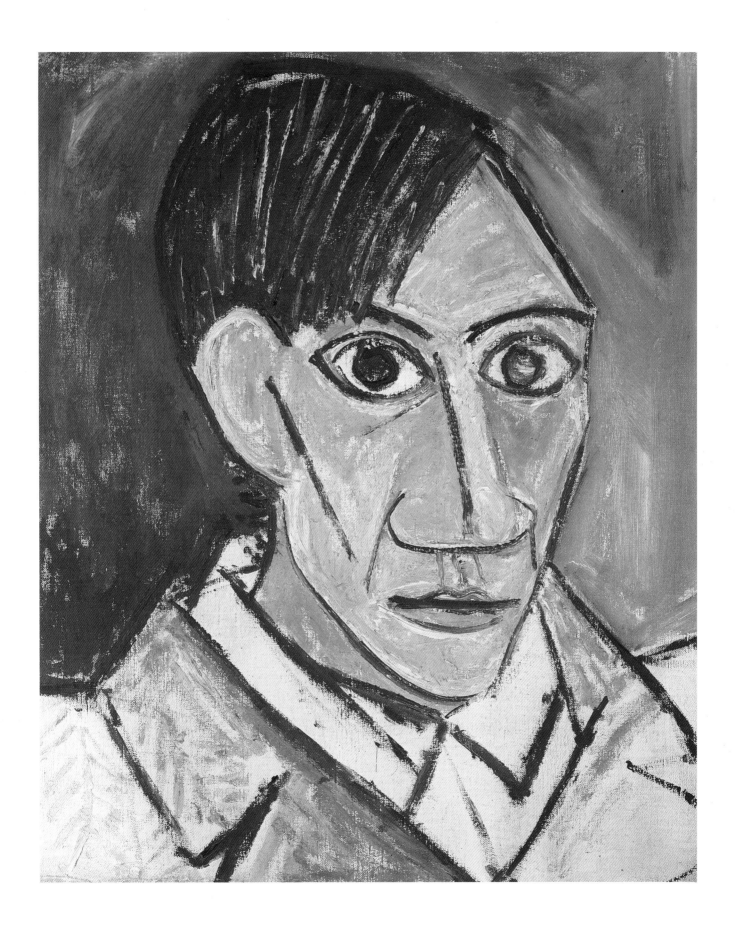

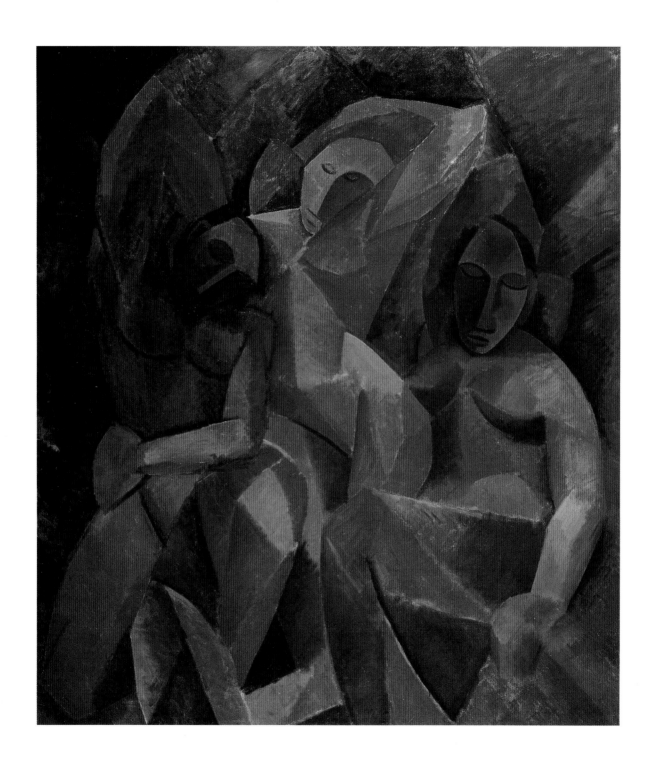

Three Women

1908–1909, oil on canvas; 78¾ x 70⅛ in. (200 x 178 cm). The Hermitage Museum, St. Petersburg.
Picasso developed the figure and its relation to surrounding space through
ideas he discovered in African art. The issues eventually became the basis
for Cubism but in this work there is greater stress on the abstract dynamism
of the rhythms of pose and body parts rendered through cubic planes of color.

CUBISM (1906–1921)

The genius and the psyche of Picasso, man and myth, was embedded in his personal production as an artist. To understand his complexities, we must follow him as an artist through that most complicated and intriguing of art movements, Cubism.

The Context of Cubism

Cubism is recognized as one of the seminal art movements in the twentieth century for several reasons. Although it originated from the private dialogue between Pablo Picasso and the French artist Georges Braques from about 1907 through 1914, it was enjoined by a large number of other like-minded artists. First in Paris, then across Europe, its principles were broadened into an art movement that reshaped not only painting but sculpture, architecture, design, and, to a lesser extent, literature. Its basic theories and ideas were modified by the development of abstract art around 1912 and became the partial basis for the dominant art form for much of the twentieth century, abstract geometric art.

The popularity of the movement was due to the various ways artists and writers accepted it as the voice of the new century, a century which ushered in the vital energy and technological excitement of electricity, automobiles, and flight. Others saw it as the visual parallel to new approaches to the material world developed in philosophy and the sciences. Cubism gave voice to a new spirit concurrent with the new millennium across the broad spectrum of Western culture. One writer spoke of it not simply as a set of reformulations in the art world but, employing the German phrase, as a new *zeitgeist*, a new "spirit of the time." It was less a "style" of art and more a new way of looking at and recognizing the modern world. But these were broad overviews, several claimed at the time and many others offered through hindsight. While Cubism was doubtlessly a revolution, like most such it began more simply for those involved.

Picasso spoke and wrote very little, as was his way, about the nature of the changes he was undertaking. He most likely did not suspect, during his early formulations, that an entire movement would follow from his experiments of 1907. There was deliberation, but it had a great deal to do with what Picasso and other artists, both before and after him, knew they did *not* want.

The Renaissance vision of art effectively ended with the death of Cézanne in 1906, even if the full implications had not yet been worked out. The concept of a painting as a kind of space-box—as a window that allowed a viewer to peer in and see the illusion of a "real" world unfold in a logical way according to rules of atmospheric and linear perspective worked out in the fifteenth century—was no longer valid. The Impressionists, whose works were known across Europe by the late 1880s, had begun to reformulate the concept of realism.

The interpretations of Impressionism as a vision of the world somehow "romanticized" by the soft blurring of reality derived from dabs of bright color is a modern one at odds with the Impressionists' original aims. They and several of the post-Impressionists, particularly Paul Cézanne who learned his lessons with them, were concerned with repudiating reality proffered by the Renaissance vision of the world. They replaced it through ways in which they felt they personally saw or knew the real world, outside the studio setting of academies, bereft of the lines and much of the dark modeling of three-dimensional forms set out separately in space. They considered themselves realists—in search of what was real—using flickering lights to colored planes.

There is no trickier or confusing word in the art world than *realism* but Picasso and the development of Cubism were certainly heirs to its changing formulation. Yet the counter offers made by the Impressionists, and the response by the Symbolists and the French Expressionists, both of whom wanted

more spirit or emotion in the modern world than had been allowed by the new realism, were not of great interest for Picasso in the development of Cubism. Matisse and Picasso represented two alternate, competitive, and antipodal visions. Although their lifelong friendship was based on mutual respect and, to some extent, common roots, Matisse's vision is seen as expressionist and decorative; to Picasso and Cubism "realism" or, more accurately, the concept of the real, was central.

What the two shared were a grounding in Symbolism, a mutual admiration for ethnographic art (albeit with quite different emphases), and the broad-based awakening in the arts to a fuller awareness of the processes and means of creating art. As the young Symbolist painter and theoretician Maurice Denis had declared in 1890: "Remember that a picture—before being a war horse or a nude woman or an antecdote—is essentially a flat surface covered with colors assembled in a certain order." Artists now considered the means of creation concurrent with or even prior to the story or subject matter. Followed in another direction, this proved to be the basis for "abstract" art, but that was a development carried out by others, certainly not Picasso, who never left his concern for the object. Despite the visual confusion created in viewers by Cubism, there was an adamant refusal to fully disengage their vision and response to the physical world.

What was new and newly shared in the avant-garde art world of Paris was the dawning realization that art could constitute its own world. Art's relation to the physical world outside of art could be renegotiated

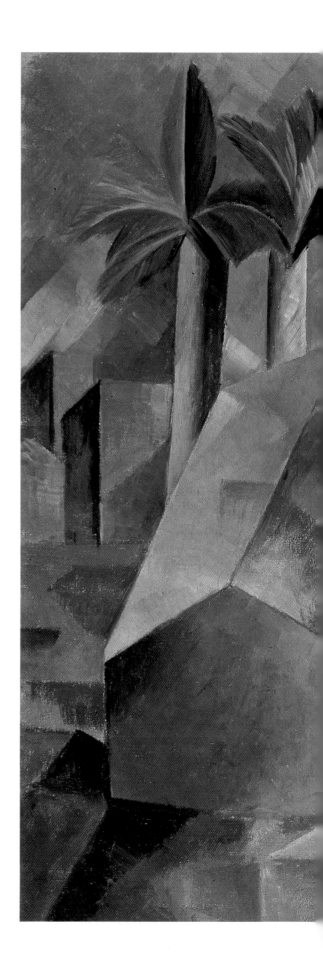

Factory at Horta de Ebro

1909, oil on canvas; 20⅞ x 23½ in. (53 x 60 cm).

The Hermitage Museum, St. Petersburg.

Picasso painted an important series of landcapes in Spain during the summer of 1909, under the influence of his friend and colleague Georges Braque. In them he aligned and interlocked geometric planes to produce a more cohesive vision of related forms.

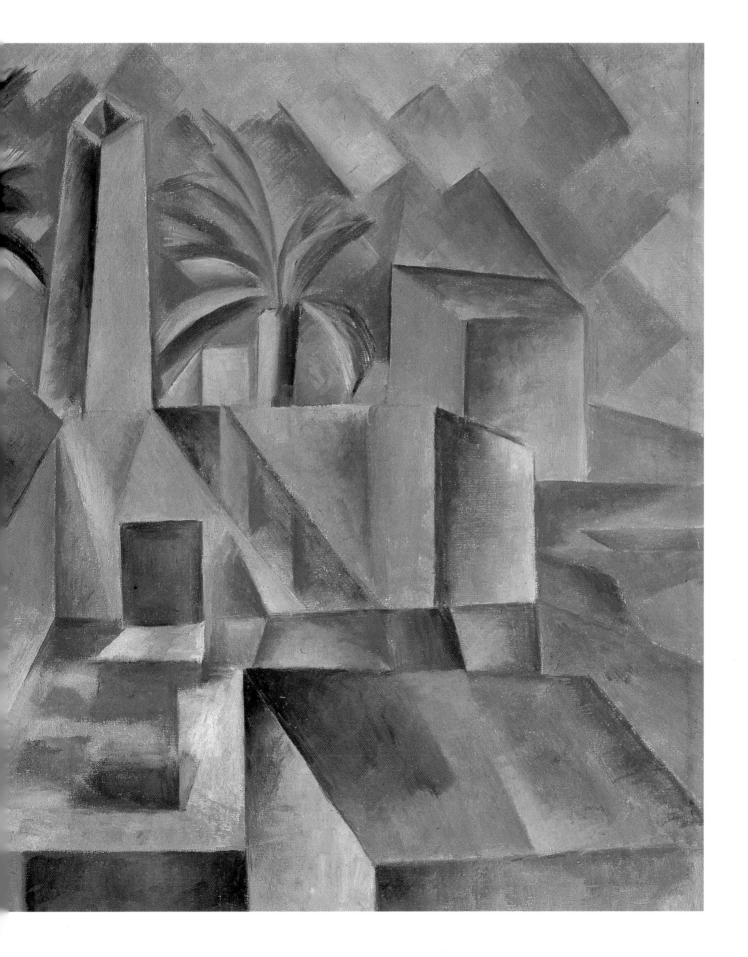

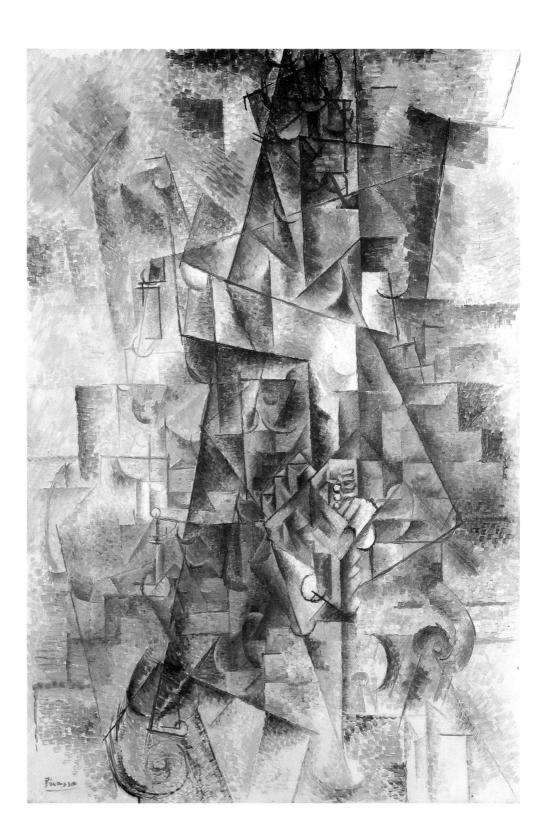

The Accordionist

1911, oil on canvas; 51¼ x 35¼ in. (130.2 x 89.5 cm). The Solomon R. Guggenheim Museum, New York.
Almost inseparable from the experiments of Georges Braque, works such as these are considered the high point of Analytic Cubism, when identifiable form almost disappears.

through whatever conditions the artists felt were significant. In short, each artist or group of artists became self-conscious of art as an entity apart, and they could define it through their work, not to mention through their words, into general if radically different understandings. This was the beginning of a deluge of art theories, which would play a new and important role in modern art. Written manifestoes filled with claims and ideas from artists and movements proliferated. Ironically, the art of Matisse and Picasso gave rise to much theory but for the most part both artists chose to develop their statements through their works. Picasso remained very silent as he began to formulate the basis for Cubism via private experiments with his colleague Georges Braque.

Braque

Among those who came to the Bateau Lavoir to see *Les Desmoiselles* in 1907 were the art dealer Daniel-Henry Kahnweiler, who became a major disseminator of Cubism, and Georges Braque, a French painter introduced by the poet Apollinaire. Braque's father and grandfather had been house painters and the young Braque had come to Paris by bicycle from the coastal city of Le Havre in 1900 to continue his practical work in house painting and interior decoration. Sidetracked by artist friends, he met the Fauve painters in 1904 and was selling well with paintings in the Fauve style by 1907. But he too was affected by the recent exhibitions of Cézanne's works, whose structural compositions were well known among Parisian artists by this time, and turned to painting landscapes that reduced nature to broad, geometric patterns.

While it has often been written that it was Braque's meeting with Picasso in the late fall of 1907 that turned him to Cubist experiments, Braque was actually well advanced in producing a new type of pictorial structure—called in hindsight proto-Cubist—prior to that fateful meeting. Upon seeing *Les Desmoiselles*, Braque was as confused as most others yet he recognized a kindred spirit. What *Les Desmoiselles* seemed to urge on him was the conviction that this rigorous new geometry could be applied equally to the human figure. He returned to his studio to repaint a large nude female form, *The Bather*, and the following summer at l'Estaque, a fishing village outside of Marseilles where Cézanne had paint-

ed, he returned to landscape painting. Here he produced the first truly Cubist pictures by using a modification of Cézanne's technique. The sense of space in these new landscapes is derived from large, volumetric colored cubes used to represent form.

When Braque submitted his new works to the Salon in the fall of 1908, the jury of Fauve artists judged them too inconsequential and accepted only two. Matisse himself, one of the jurors, characterized the paintings as using *petite cubes* ("small cubes"). Angered, Braque withdrew all of his works and turned to Kahnweiler for a one-man exhibition that November. In a review, the critic Louis Vauxcelles, who had coined the term *Les Fauves*, now used Matisse's characterization of Braque as having reduced "everything, landscape, and figures and houses, to geometric patterns, to cubes." Like so many terms in art, from Gothic to Fauve, Cubism was first employed in a derogatory way. The Kahnweiler exhibition was acknowledged as the first "Cubist" exhibition and by the close of 1909 the term Cubism was widely accepted.

A cross-fertilization of ideas occured when Picasso, who loved the human form above all subjects, returned to landscape painting during his visit to Spain in the summer of 1909. His *Factory at Horta de Ebro*, like many of his views of this small town, constructed buildings from what seem like crystalline planes. The successful relation to similar planes used in the shadows, hills, and sky stitch the forms together in such cohesive fashion that they seem to arise out of some overall base matrix. These landscapes were Picasso's first fully realized Cubist paintings, one year after the works of Braque.

The noted Picasso scholar William Rubin has argued that it was Braque's new, Cubist conception of space, always a primary concern among landscapists, developed by 1908 that redirected Picasso's from stylized African figures to attempt to integrate human forms into the surrounding space, as seen in his reworking of *Three Women*. Braque seemed to provide an anchor for Picasso, (a solution for his indetermination) following *Les Demoiselles*. Thus the venture was joined; a dialogue unique in the annals of art history begun, by two artists who initiated a private series of experiments until they were separated in 1914 by the start of World War I.

Woman with Pears (Fernande)

1909, oil on canvas; 36¼ x 28⅞ in. (92 x 73.1 cm).
The Museum of Modern Art, New York.
Picasso applied his new artistic geometry to his companion Fernande Olivier, developing an ability to reconstruct the face through smaller planes of color. The "planar" look also results in an oil painting that suggests itself as three dimensional, shallow-relief sculpture.

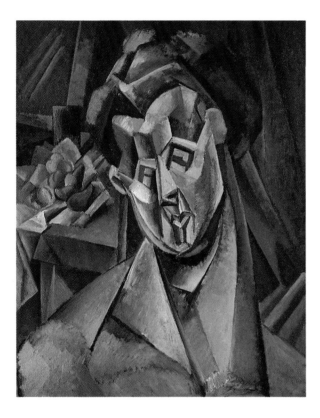

Categories of Cubism

The works painted in Horta de Ebro (now known as Horta de San Juan), Spain, in the summer of 1909 were not only Picasso's first fully realized Cubist paintings, they initiated a period known as Analytic Cubism, to be followed in 1912 by a period called Synthetic Cubism. Artists who later become Cubists and made of the style an art movement, such as Juan Gris, attempted to distinguish themselves from early Cubism by claiming to be practitioners of Synthetic rather than Analytic Cubism, but neither Braque nor Picasso made such distinctions. For them, Cubism was a ongoing experiment rather than the creation of discreet works or separate periods.

Picasso was not one to focus his work through a sense of finality, preferring to see his artistic creation as a continuum. Even so, the differences between Analytic and Synthetic Cubism help explain what at first seems very foreign and provides a good introduction to understanding many of the issues central to the art of the twentieth century. As with much of Cubism, and owing to its relatively silent originators, explanations developed both during and after the movement.

Analytic Cubism

Analytic Cubism is frequently characterized by the processes of painting as much as by how the works look. These are visible in the Horta paintings, such as *Factory at Horta de Ebro* and *Woman with Pears (Fernande)*. The overall characteristic of Analytic Cubism is exactly what one might suspect—an "analytic" process, as first introduced by Cézanne, by which forms in the world are broken down into planes of color. This was a new way of thinking about the relationship between painting and the real world, one that had to be developed through experimentation.

As Picasso and Braque looked into the landscape they began to reverse the normal process of applying paint, as Braque phrased it, "bit by bit," painting the background first and the foremost planes last. As a result, normal perspective, by which a picture recedes into distance, is reversed. A Cubist picture tends to advance toward the viewer. Because the distance is curtailed, a reading of the canvas from side to side or from top to bottom begins to equal a recessional reading.

Second, there was a concern for how a viewer or a painter moved around in the painting. Here too they followed the lead of Cézanne by eventually developing techniques which allowed one plane of color to relate to other color planes. At first this was done by relating the color and alignment of the "cubes" that constituted the forms. Cubes were related by placement or similar color. In the earlier paintings the planes were kept fairly separate, as seen in *Woman with Pears (Fernande)* of 1909. However, this was still too much like Renaissance painting, with its separation between shapes and forms. Eventually they opened the edges of the planes to allow a "passage" from one to the other. When the space too is represented in terms of colored planes and opened, it becomes very difficult to distinguish form from space.

Head of a Woman (Fernande)

1909, bronze; 16¼ in. high (41.3 cm). The Museum of Modern Art, New York.
At crucial points in his investigation of new ways to represent the old problem of three-dimensional form on a two-dimensional canvas, Picasso turned to sculpture. The parallels between this painting and sculpture are apparent.

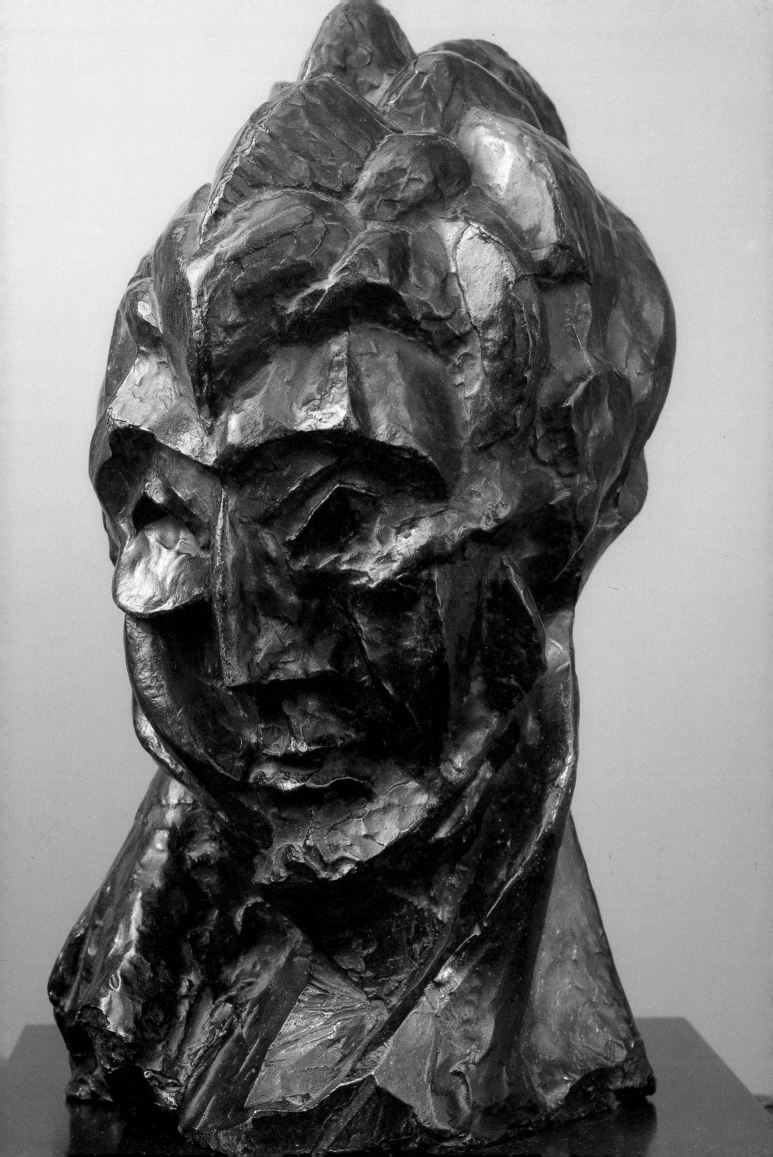

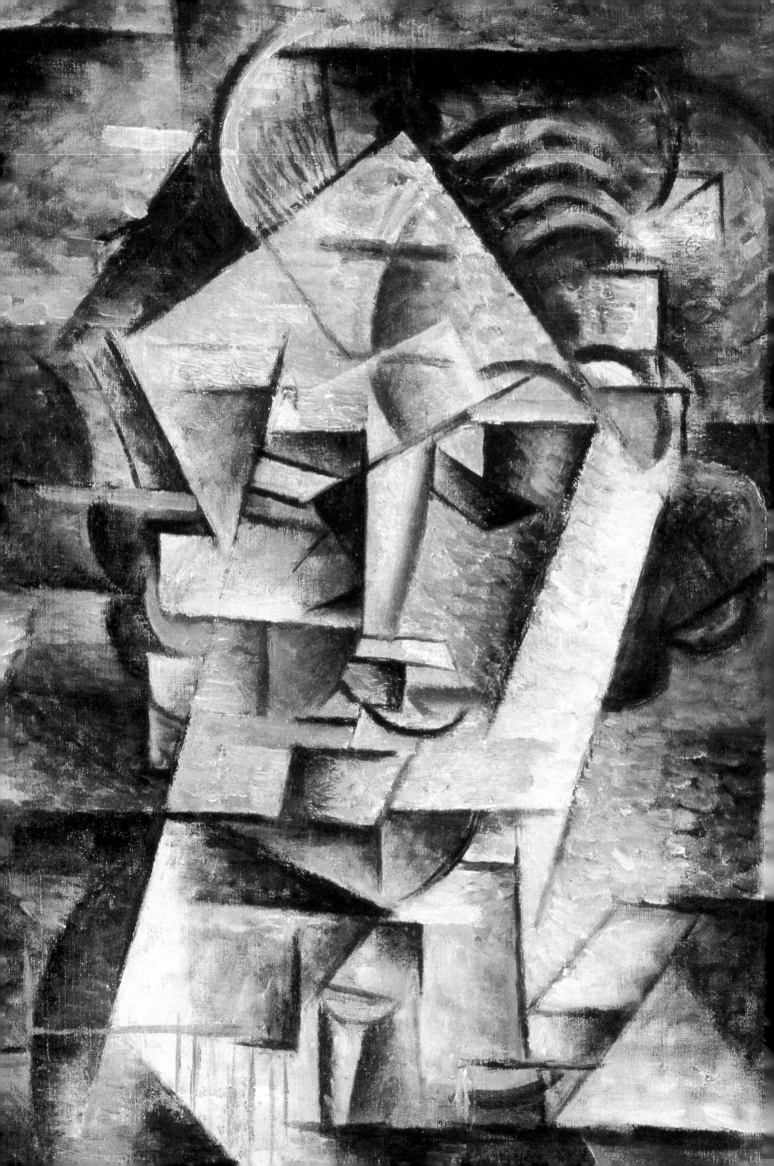

One consequence of forms which were no longer separated was their similarity to relief sculpture. These works looked like sculptural forms in shallow relief, attached to a common support or back plane. Since the apparent projections did not seem to be high, they were often referred to by the same term as used in sculpture—"bas," or shallow, relief forms. This correlation between the three-dimensional art form of sculpture and the two-dimensional art form of painting was purposefully confusing.

Since the Renaissance the task of painting was to utilize a flat surface to convince through illusion that real—by which was meant three-dimensional—forms were displayed in front of a viewer. Once the desire to continue this illusion and those techniques were cast aside the fundamental problem remained; in other words, there were three-dimensional forms to be painted in a two-dimensional medium. To help provide new solutions to an old problem, Picasso turned to sculpture.

A comparison between two portrait heads of Fernande Olivier from 1909, one painted and one in bronze, illustrates Picasso's thinking and one of the central problems of Cubism. The painted portrait of Fernande (*Woman with Pears*, 1909) likely inspired the slightly later *Head of a Woman (Fernande)* in bronze. The painting had already broken down physical parts of the head and neck into faceted planes of differing color, organized into new relationships which more or less resembled her face. But here she was less an individual person and more an assemblage of masses through planes.

The same process, in reverse, was followed in the bronze bust, with an additional twist of the head into space. The source for sculpture derived from a new architecture of the human body begun in painting. Picasso's interchanges between painting and sculpture, the idea of having them share the same problems, remained an issue central to his work as well as with much of the experimentation being done by European painters of the time. Eventually he invents a wholly new tradition in sculpture, but for the

Portrait of Daniel-Henry Kahnweiler

detail; 1910. Gift of Mrs. Gilbert W. Chapman in memory of Charles B. Goodspeed, The Art Institute of Chicago, Chicago.
A close-up view of Kahnweiler's face shows not only the recognizable physical features of his nose and hair but, in addition, the dynamics of the alignment of planes as they alternate directional patterns of light and dark. The stasis of the painting gains the visual motion of sculpture.

Girl with a Mandolin (Fanny Tellier)

1910, oil on canvas; 39½ x 29 in. (100.3 x 73.6 cm).
Nelson A. Rockefeller Bequest, The Museum of Modern Art, New York.
As the developing language of Cubism was applied to the full human form, one senses the whole of the form of the model while the surrounding space gained a new presence and presented new problems to be solved.

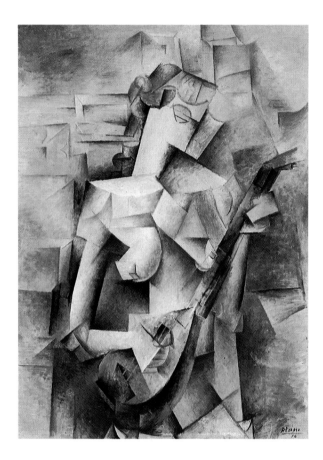

Analytic phase, the relationships between two and three dimensions were central.

Rarely did Picasso work directly from a model or sitter, as he did with Gertrude Stein, but the new concern for form in 1910 demanded a three-dimensional form in front of him. When Fanny Tellier, the model for *Girl with a Mandolin* quit after numerous sittings, Picasso was so dependent he left the work as it was. His investigations began to solidify in a series of portrait heads for which his sitters had the patience to remain. Two of them, portraits of his dealers, Vollard and Kahnweiler, show the rapidity of his development.

The *Portrait of Ambroise Vollard*, done in the spring of 1910, looks as if a mirror had been smashed while Vollard looked into it. His facial identity remains clear but the relation between the parts is no longer easily apparent. The forehead is elongated and, like

the center planes of his coat, seems to bow out at the viewer in the manner of bas-relief sculpture. It is almost easier to conceive of this "painting" as constructed from something more physical, like modeling clay or cardboard. These kinds of ideas were much on the mind of Picasso and he explored such shifts more fully in Synthetic Cubism.

That autumn he painted his *Portrait of Daniel-Henry Kahnweiler* with practically the opposite result. The figure is almost lost within the fragmentation (or "analysis") but the viewer can discern Kahnweiler's hands, held together in the lower part of the painting, as well as the central part of the head, with his characteristic strong nose and parted hair. The nose and eyes each lie on a separate plane and the viewer now relies on hunting for pieces of the body as if reassembling a puzzle. The chest area appears hollowed out since its dark tonalities tend to recede from the lighter areas of face and surrounding planes.

Once again, the work seems modeled from some physical, plastic material, as if clay or a thick modeling paste had been added or pulled away. Picasso is reported to have kept several large balls of clay around his studio to make experiments in three-dimensional and two-dimensional effects. Indeed, the center of Kahnweiler's chest pulls farther away than the edges, giving it a slightly concave shape, and the head is slightly convex. These are a painterly and optical translation of the concavities and convexities of the African sculpture the artist came passionately to admire and collect.

By 1911 Picasso's painting *The Accordionist* seemed entirely abstract, the subject identifiable only by the title. Little of the form or identity remained substantial. Even the application of the paint within the colored planes seems insubstantial, applied in small bricklike strokes. The only solidification was the darker triangle in the center of the composition, where the smaller fragments are overlaid with larger planes. Here and there, though, are scattered pieces, such as the musician's fingers on the viewer's right, poised above the accordion buttons or studs, with the pleats of the accordion cascading to the left. What the viewer confronts is more the concept of a painting than the physical identity of an accordionist.

Painting, while tied to the physical world, had become its own world and now began to dictate its own terms to the real world. Picasso once commented that art was "a lie that makes us realize truth, at least the truth that is given us to understand." The truth of painting lay in painting, not in the illusion of representation; its power came from its ability to offer a new vision of reality. This was to be one of the major contributions, and complications, of modern art.

Fragmentation also demanded from viewers the "time" to find the pieces and "read" the relationships between parts. This sense of time has been suggested as a correlation to Albert Einstein's dissolution of matter into a continuum between space and time. Picasso did not read or know Einstein's work. In fact Picasso had a disdain for mathematics, favoring intuition, but the painters who followed in the wake of his experiments made much of the issue.

Time in painting was no longer based on the unfolding of a story or event but now represented the "fourth dimension." The concept was also widely disseminated among European intellectuals to mean something more mystical. Science was, or could be, a road to the metaphysical. The followers also claimed a more linear mathematical basis for much of Cubism. They developed an underlying grid, which once penciled in could direct the placement of the colored planes. However, fsor Picasso there could be no system or formula, since each work, as part of a continuum, emerged out of its process. Angry at their reduction of his art to formulas, he is reported to have called his friend Juan Gris a pimp of Cubism. Nor did Picasso and Braque exhibit their work in the Paris October Salon of 1911, which for the first time included a large Cubist section. The more absent Picasso remained, the more he left it to others to provide interpretations.

Picasso was fully aware of the literal play between the two different worlds—the world itself and the world of art—and confusion was an integral and desirable element. To enhance this play first Braque then Picasso introduced words in such paintings as *Man with a Pipe* (summer, 1911) and *"Ma Jolie" (Woman with a Zither or Guitar)* (winter, 1911–12). Words were of the real world, generally considered outside the illusionary realm of visual arts, appropriate to, at best, design and advertising. But they became integral for Picasso and Braque for reasons better developed in a discussion of Synthetic Cubism. This innovation came during the summer of 1911, when both stayed at an old villa in Céret, a town in the French Pyrennes, and where, according to an oft-quoted phrase by Braque, "we were guided by a common idea . . . rather like being roped mountaineers."

The Accordionist

detail; 1911. The Solomon R. Guggenheim Museum, New York.
A detail of this painting shows the remnants of figuration with what appear to be fingers, the studs of the accordion, and the cascade of planes representing its pleats. The planes often open one to the other to give a sliding effect.

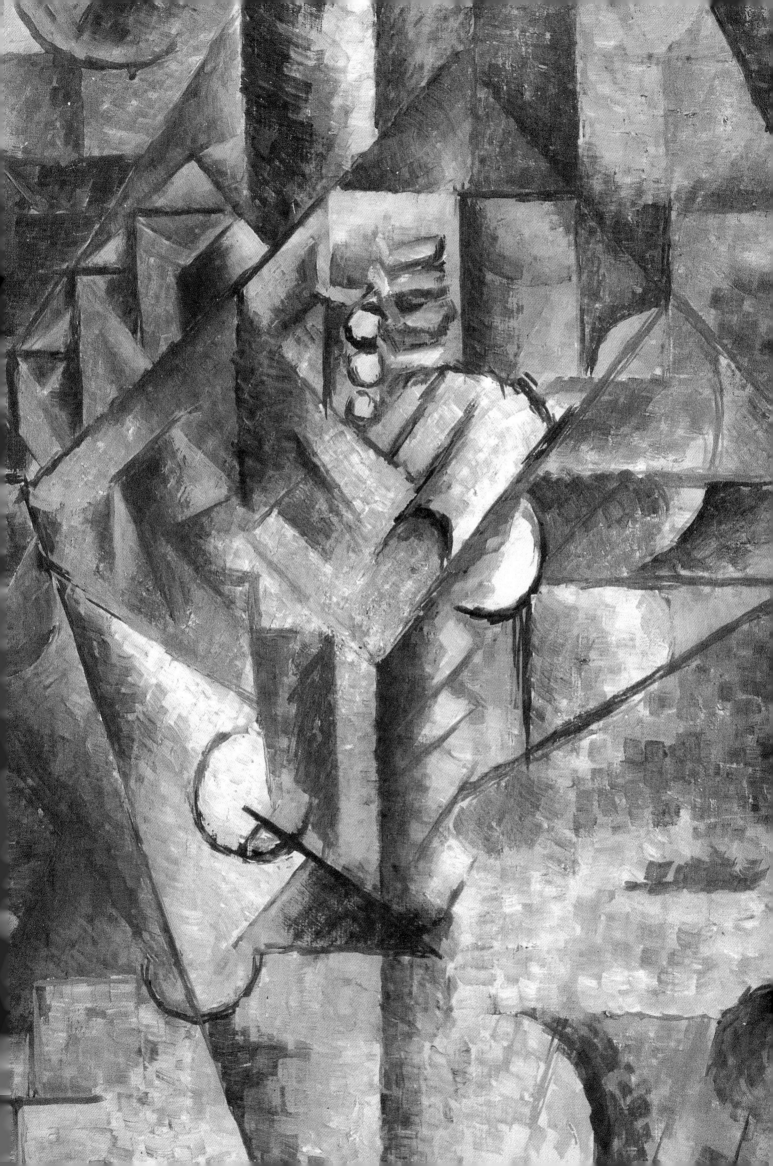

"Ma Jolie"
(Woman with a
Zither or Guitar)

1911–1912, oil on canvas;
39³⁄₈ x 25³⁄₄ in. (100 x 65.4 cm).
Acquired through the Lillie P.
Bliss Bequest, The Museum
of Modern Art, New York.
The words "Ma Jolie"
were reportedly Picasso's
"pet name" for his new
love, Eva Gouel (Marcelle
Humbert), derived from
a popular love song,
which roughly translates
as "my pretty one (*ma*
jolie), my heart says hello."

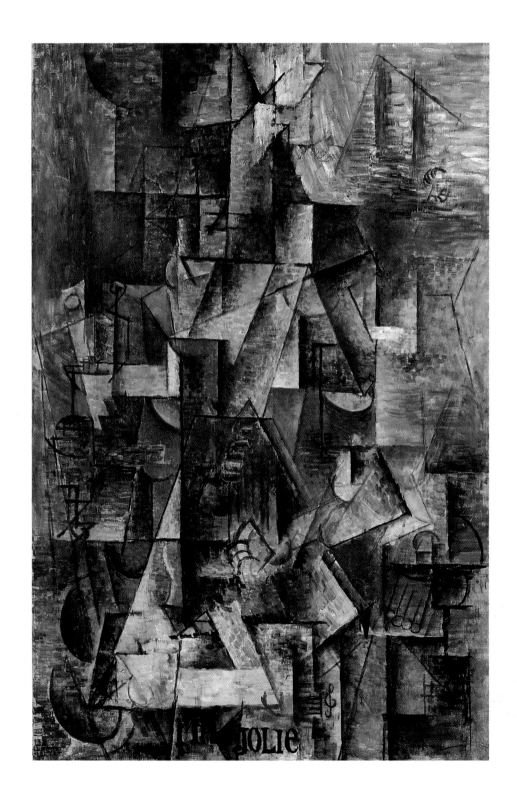

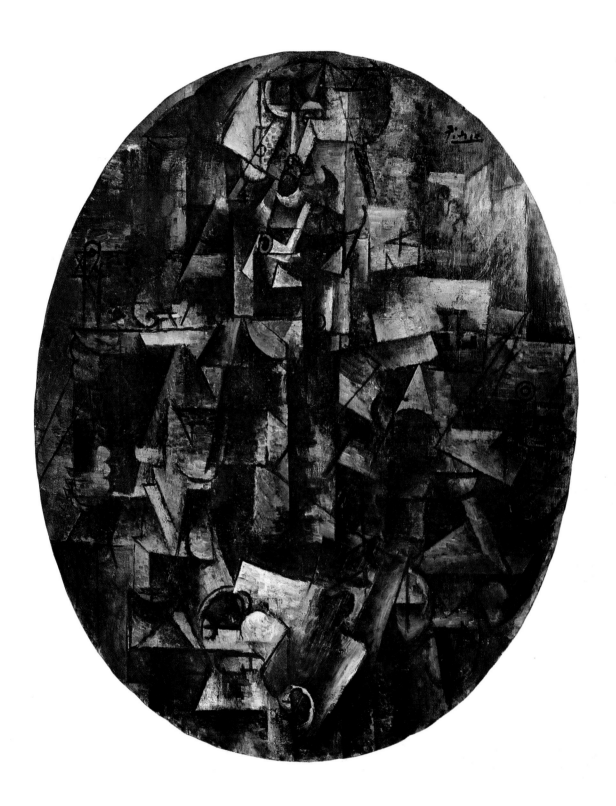

Man with a Pipe

1911, oil on canvas; 35¾ x 27⅞ in. (90.7 x 70.8 cm). Kimbell Art Museum, Fort Worth, Texas.
The late summer of 1911 in Céret was an intense period of interaction
between Picasso and Braque, producing their first experiments with
reproducing precisely "real" fragments of letters and words in their paintings.

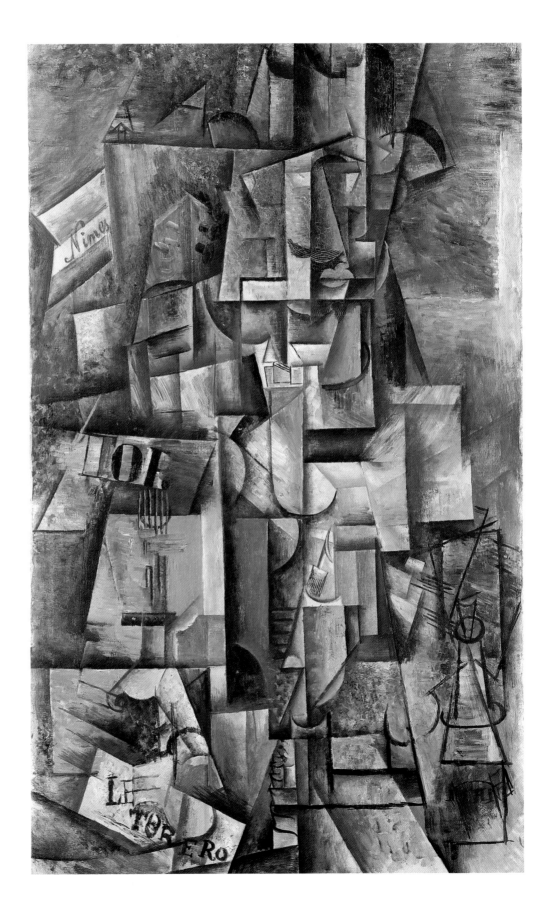

The Aficionado

1912, oil on canvas;
53⅛ x 32¼ in. (135 x 82 cm).
Gift of Raoul La Roche,
Kunstmuseum, Basel.
The diaphanous color
planes began to solidify
and simplify as Braque
and Picasso turned
from an "analytic" to a
"synthetic" approach to
form and painting. The
bullfight fan is as recog-
nizable as the figures
from works in 1910.

From the Analytic to the Synthetic

Analytic Cubism had created pictures by breaking down (analyzing) form and space into greater abstractions of lines and planes, the new terms of art. It took several years of effort for the artists to understand the problems and develop the vocabulary to formulate a truly pictorial way of approaching nature. The apex, perhaps crisis, of the analytic came in the winter of 1911–12 with paintings such as "*Ma Jolie*," partly because the segmentation was pushed to the point where the subject matter was referenced only by the title of the work. The paintings from this period have been described as "metaphysical," meaning that the true subject of such works were abstract qualities such as light, space, and the physical qualities of paint itself. Form had become incidental to the process. Reality, as it had been defined in painting for hundreds of years of making "pictures," was slipping away.

At this point Braque and Picasso began to develop new ways to assert the physical reality of art, especially by developing two new techniques whose consequences for modern art were vast: collage and *papier collé* ("pasted papers"). However, it was not the object in space they returned to for their realism; the physical components of both painting and sculpture which they had worked to establish offered them the new terms of reality, as they began to add parts of the real world. Out of the logic of the analytic came a new sense of construction, the building or synthesizing of a new reality. This "synthetic" form of Cubism was even more fertile than the Analytic form. It lasted into the 1920s and provided the point of departure for the Cubist movement in Paris and across Europe.

Many of the changes were gradual. In a painting such as *The Aficionado* from mid-to-later 1912, much of the illegibility of the Analytic remains. Colors remain restrictive and monochromatic. The use of planes of color continues but they are less airy and light, more hardened and solid. The color planes take on a more concrete identity, less open to the interpenetration by the others. This did not mean that *The Aficionado* was particularly more decipherable. The

viewer remained in search of clues, and had to be content with a floating eyebrow, mustache, and set of lips, none of these connected.

One of the explanations for reconstructing the world through sets of clues like this, as in a detective story, is not only the incorporation of time but a more accurate correlation to the way people actually see, know, and act in the world. Knowledge of the world is fragmentary and schematic. The faster the modern world moves the more this seems true and the artists celebrated their contemporaneity in many ways. Picasso nicknamed Braque "Wilburg" perhaps because he saw a parallel in the nature of their experimental creative "flights" and those of the Wright brothers. Of course that made Pablo "Orville."

Then too the use of letters and words remains a strategy—and it is useful to think of Picasso in terms of strategies—developed by mid-1911 in Braque's work and quickly followed by Picasso. The meanings of the use of letters and words are many. On the physical level, letters, especially when machine-stenciled rather than simply painted by hand, were physically flat and their insertion drew attention to the flatness of the canvas. Their flatness and the resulting realism reinforced several central tenets of Cubism—the new reality of Cubist painting was its flat, non-illusionistic, and constructed qualities. Simultaneously, the terms of the puzzle were doubled; words belonged to the real world but their physical realm was that of art. These were but two levels of interpretation the painters exploited.

The references words had to the real world—the world beyond the painted object—were often utilized on a literal level. Words often referred to local newspaper titles, events, or even personal statements, such as to celebrate love, as Picasso did for the new woman in his life, Eva Gouel, in *Ma Jolie (Woman with a Zither or Guitar)*. Picasso went so far as to write across one still life, *The Scallop Shell* (1912), the phrase *Notre Avenir est dans l'air* ("Our future is in the air"), in reference to flight. But he also omitted enough of the letters in the words to make a clear reading impossible. Most of the words are fragments, like his subjects, and even the fragments could have a double meaning.

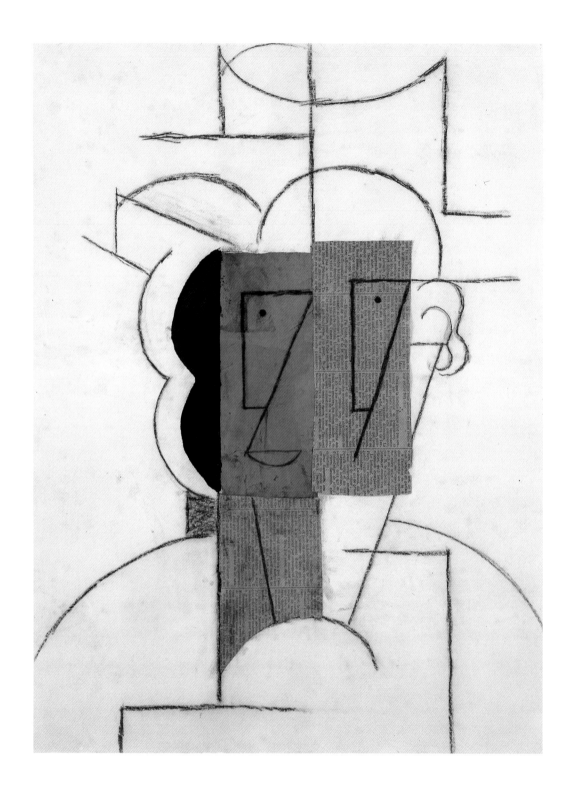

Man with a Hat

1912–1913, charcoal, ink, and pasted paper;

24¹/₂ x 18⁵/₈ in. (62.2 x 47.3 cm). The Museum of Modern Art, New York.

Picasso's use of glued papers (*papier collés*), following Braque, often employed
humor to raise serious questions. Here, the techniques of modeling through
light (the newspaper) and dark (the blue rectangle) construct an alternative to
the academic techniques of modeling through the application of gradual light.

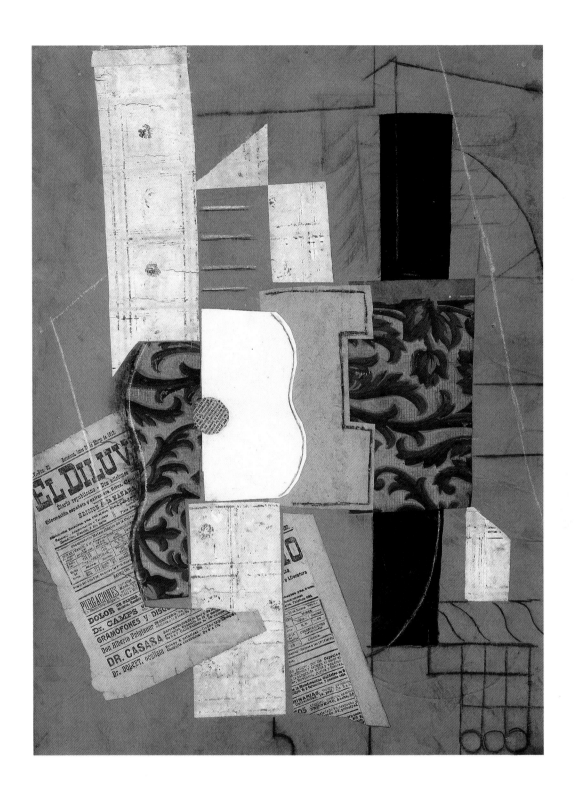

Guitar

1913, charcoal, crayon, ink, and pasted paper; 26⅛ x 19½ in. (66.3 x 49.5 cm).
The Museum of Modern Art, Nelson A. Rockefeller Bequest, New York.
The severe restrictions of color in the "analytic" phase of Cubism gave way
to an increased range of colors in the "synthetic" phase, and by 1913 a more
decorative note began to develop in Picasso and other painter's works. Cubist
space in painting defined the nature of modern space as flat yet interactive.

In one of Picasso's most famous works from the Synthetic Cubist stage, *Still Life with Chair Caning* (1912), the letters "JOU" appear, as they did in *The Scallop Shell* and several others. They refer to the Paris newspaper, *Le Journal*, a reference intended to snap the viewer away from art and back to the real world. However, they are also the first three letters of the French verb *jouer*, a word with several meanings: "to play, to amuse oneself, to run the risk."

Picasso's early harlequins were melancholy clowns but they served another aspect of Picasso's personality as well. Much of Cubism and Picasso's later work cannot be understood without recognizing the seriousness of play and good humor. It is an integral part in the risks he and Braque took in art. Humor and irony were factored in his oscillation between the realms of art and the realms of the real world. For hundreds of years art had been the illusion of the real, but now safely ensconced in its own world, art could reach out to challenge the categories; it was surely part of the real, and where one began and the other ended was a question now often posed. Other components in *Still Life with Chair Caning* developed the same issue on greater levels of play.

The chair caning in the painting was a reproduction of chair caning mechanically printed on oil-cloth and glued onto a canvas half covered by oil painting. The real was mixed with art, which had previously been the unreal, or illusionary. In addition, the "real" chair caning was itself an illusion, a reproduction on oil cloth. Which then was the appropriate realm for illusion or reality since each could be located in the other? This inter-play posed serious questions. To complete the ensemble, an actual rope surrounded the oval canvas to simulate the twisted wooden moldings found on older paintings. It was Picasso's first collage, from the French "to glue or paste," the mixing of elements, which was to have a long, productive role in the fine and graphic arts. His collage technique grew out of two sources, aside from Braque.

Still Life with Chair Caning

1912, collage of oil, oilcloth, and paper on oval canvas surrounded with rope; 10⅝ x 13¾ in. (27 x 35 cm). Musée Picasso, Paris.
Delighting in the new interplay between illusion and reality, glued papers and pieces of the real world were introduced here by Picasso into the illusionistic world of painting. The actual rope surrounding the oval is interpreted as a replacement for the ornate wooden frames of traditional painting.

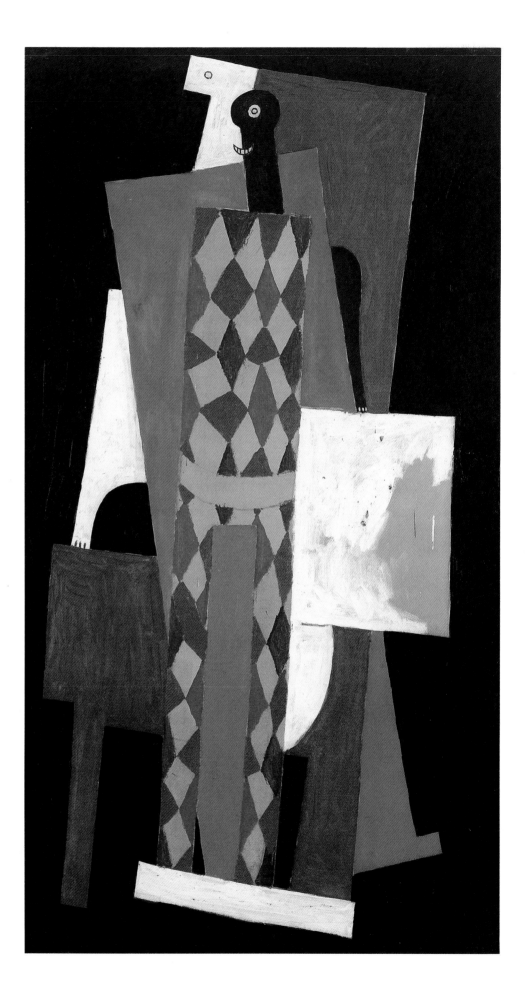

Harlequin

*1915, oil on canvas; 72¼ x 41⅜ in.
(183.5 x 105.1 cm). Acquired
through the Lillie P. Bliss Bequest,
The Museum of Modern Art, New York.*
In a letter to Gertrude
Stein in December 1915,
Picasso wrote, "My life is
hell . . . However, I have
made a picture of a harlequin
that . . . is the best thing
I have ever done." The
harlequin symbol remained
an integral part of the artist's
life and initiated a new
series of works, culminating
in *The Three Musicians*.

He remembered that his father, Don José, pinned cut pieces of paintings on his canvases when trying new ideas. Additionally, of course, there was his own touchstone—sculpture.

Earlier the same year Picasso had again turned to sculpture at a crucial period to verify and resolve problems. His *Guitar*, likely dated to early 1912, was a revolutionary work of sculpture, which grew out of Analytic Cubist painting but bridged back into Synthetic collage. That the *Guitar* derived from analytic painting was visible in the use of flat planes, now of metal, and its open volumes. It looked much like the guitars found in the hands of his painted musicians. Yet its reconstruction in terms of metal was revolutionary on two levels.

The guitar, as a form, was more coherent than the painted versions but, ironically, not more solid despite its construction from metal. The top of the guitar, its visually solid portion in the real world, was removed to the bottom to reveal the "truth" of an open volume. Everywhere solidity is replaced by volume. The interplay between solid and volume in favor of volume reversed the normal understanding of sculpture as mass, a conceptual shift of vast implications for modern sculpture, architecture, and design.

Further, the guitar was constructed from industrial material—sheet metal and wire. The use of such materials was unusual, though quickly adopted by others, but its radicality was in the concept of construction. Sculpture had always been made one of two ways—either by carving away what was unwanted or by casting melted metal into a mold. "Construction," the conscious cutting and assemblage of individual parts, offered a new process destined to become a major part of twentieth-century sculpture. It was an easy step from the concept of construction to the collage process displayed in *Still Life with Chair Caning*.

Likely inspired by Picasso's extensions into sculpture and collage, Braque added *papier collé*, literally "pasted papers," to the repertory of Synthetic techniques. Braque and his family had been trained in interior house decoration, much of which was based on using materials illusionistically. In 1912 pieces of wall paper, printed as wood grain, began appearing on paper and canvas next to Cubist planes in oil and charcoal, in addition to letters. In a work from one of Picasso's series of papier collé, *Bottle of Suze*, the apéritif bottle carries its own label, *Suze*, glued across large flat planes created from painting and cut pieces of papers. They rest on a combination of decorative wallpaper and clippings from newspapers.

The growth in size and simplification of the color planes was symptomatic of Synthetic Cubism, as the painters moved toward rebuilding form. The color range and tonalities also increased. A final Picassoesque touch here was the addition of an apparent forearm and hand holding a glass drawn in charcoal. The bottle of spirits momentarily shifts identity, to become a figure apparently drinking its original identity. In the midst of his assertion of new form, identity continued to be destablilized.

The puns proliferated during the Synthetic period, as if humor were now an integral ingredient, though directed to serious issues. In the *papier collé* of *Man with a Hat* from the winter of 1912–13, two facial profiles appear in what is apparently a single figure under one hat. Each profile "represents" a different dimension to the same face, but is portrayed in the new terms developed fully within Cubism. One profile is drawn over part of a regular newspaper column, beige in color, to represent the human figure in light. The other profile is drawn over a painted dark blue rectangle to represent the human figure in shadow. Renaissance values of dark and light modeling have been analyzed, replaced, and reconstructed. And to assure that the puns are literal as well as visual, the text in each fragment of newspaper refers to the body part where it is placed—nose and chest. Both artists constantly used topical references in their newspaper clippings, in ways only recently understood.

Near the beginning of World War I—a time when the French-born Braque was called to the front lines, breaking the historic collaboration—two new developments occurred. The Synthetic Cubist paintings and collages became thicker, more material and colorful. Works from late 1913 into the 1920s are often designated as "decorative," or a "rococo" form of Cubism. Broadly interpreted, it was an attempt to expand the vocabulary of Cubism at a time when the rest of Europe was adopting and modifying it. Picasso was to retain the bright colors introduced here with the broadened flat planes of Synthetic Cubism in one fashion or another for the rest of his life.

One fusion of these characteristics is often considered the climactic end of the high experimental period of the Synthetic phase. The two versions of the *Three Musicians* make emphatic use of relatively simple large planes united in deceptively complex spatial cues. The flat forms counterpointed by areas of intense color move the viewer's eye like the musical scores they play; decoration and music are synthesized. Painted in the summer of 1921, Picasso harked back to his Rose Period figures from the *commedia dell' arte* and the saltimbanques of the Cirque Médrano. They climax the end of a long series begun in 1915 with the reappearance of *Harlequin*, yet there

The Three Musicians

1921, oil on canvas; 79 x 87¾ in. (200.7 x 222.9 cm).

Mrs. Simon Guggenheim Fund, The Museum of Modern Art, New York.

The New York variation of this well-known painting is more simplified in its forms than its complement, and includes the dark form of a large dog. The darkened background tonalities and the apparently more "sinister" figure on the end of both paintings has led to the interpretation of these two paintings as harbingers of the change in psychological mood Picasso's works would soon undergo.

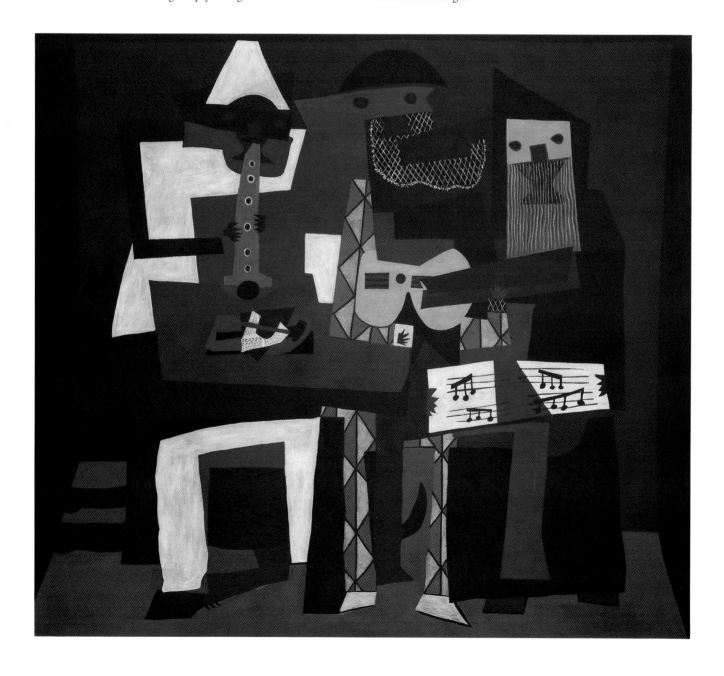

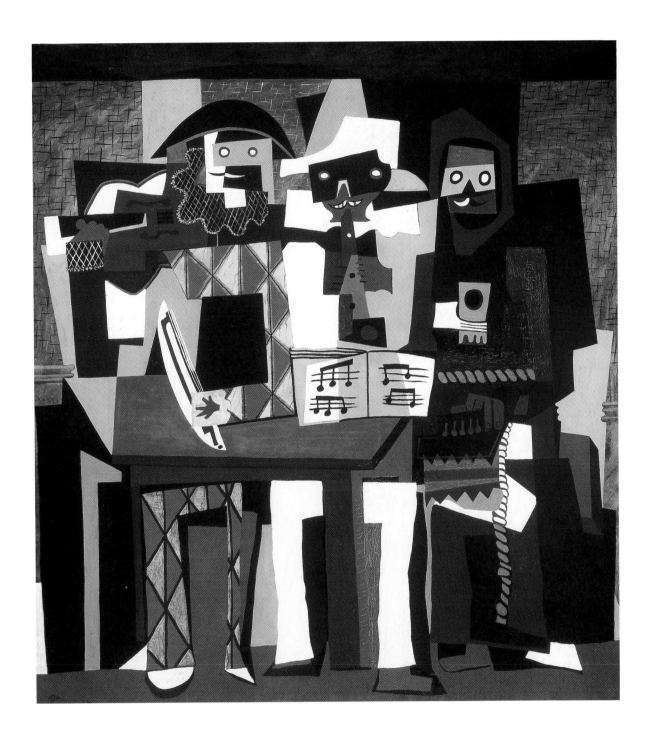

The Three Musicians

1921, oil on canvas; 80 x 74 in. (203 x 188 cm).

A. E. Gallatin Collection, Philadelphia Museum of Art, Philadelphia.

The two versions of *The Three Musicians* created in
1921 are considered the maturation of the Synthetic
Cubist style and the culmination of Picasso's series of
harlequins begun in 1915. The version in Philadelphia,
seen here, is more intricate and varied in form and color.

Glass of Absinth

1914, painted bronze with silver sugar strainer; 8½ x 6½ in.

(21.6 x 16.5 cm), Diameter at base, 2½ in. (6.4 cm).

Gift of Mrs. Bertram Smith, The Museum of Modern Art, New York.

The bitter taste of the popular green-colored liqueur was a favored alcoholic drink of many. The bronze, painted sugar cube, used to offset its taste, and the real silver sugar strainer complete the humorous reference to its reality.

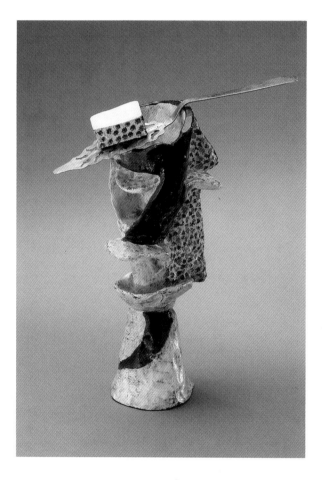

to new levels. The spiraling bronze column of *The Glass of Absinth* may owe something to the work of the Italian Futurists, who had shown their work for the first time in Paris in February of 1912, but Picasso, of course, also had his own agenda in the sculpture of this time.

Constructed works such as the *Mandolin and Clarinet* (1913–14) were composed of pieces of found wood and retained an emphatic sense of humor. Here the silly-looking clarinet is very much like a child's toy at a time when the creative play of children was admired. Unlike the *Guitar* or *The Glass of Absinth*, however, the identity of the mandolin is lost in the advanced interplay of open volumes and constructed planes. The ragged pieces of wood construction that comprise *Violin and Bottle on a Table* (1915–16) was to develop eventually into the "junk" sculpture of the 1950s and 1960s. Its painted planes of blue and white provide a new material dimension for color that would advance in the hands of architects and designers from the 1920s onward.

Picasso, the harlequin, had once again reappeared to juggle like a circus acrobat prior conceptions. Reality had become symbolized; the lines between paint, painting, and sculpture, like the distinctions between forms and space, were virtually erased. Art was now a much more conceptual undertaking. Despite their rejection of the Renaissance conditions for art, Cubist painters had advanced another Renaissance argument that artists were learned people who handled ideas, and "having the gift of inventive imagination," had the freedom to work "according to his imagination." Significantly, however, the reality that painting had always placed before a viewer—an ideal which Leonardo da Vinci believed made painting superior to all other art forms—was exchanged now for one specifically of the twentieth century, something more complex.

is something amiss. The ostensible gaiety and the humor in the construction of their individual forms do not offset a darker note sounded here. By 1921, there is a new aspect to Picasso's work, one more clearly explained outside of an analysis of Synthetic Cubism.

As a phase of his painting turns again, significant developments in sculpture occurred during the same period. The opened volumes of the cast bronze *Glass of Absinth* of 1914 were similar to those of the earlier guitar, but the bronze was painted to look like sugar and the incorporation of a real silver sugar strainer at the top pushed the relation between real and illusion

Mandolin and Clarinet

1913–1914, construction of painted wood and pencil;

22⅝ x 14⅛ x 9 in. (58 x 36 x 23 cm). Musée Picasso, Paris.

Attached to a back plane of wood the sculptural experiments from this period were constructed relief sculptures using "found" or "junk" elements.

The ensemble extends from the walls like three-dimensional Cubist paintings. The interchange between the two media is virtually complete, and Picasso would soon take leave of sculpture for several years.

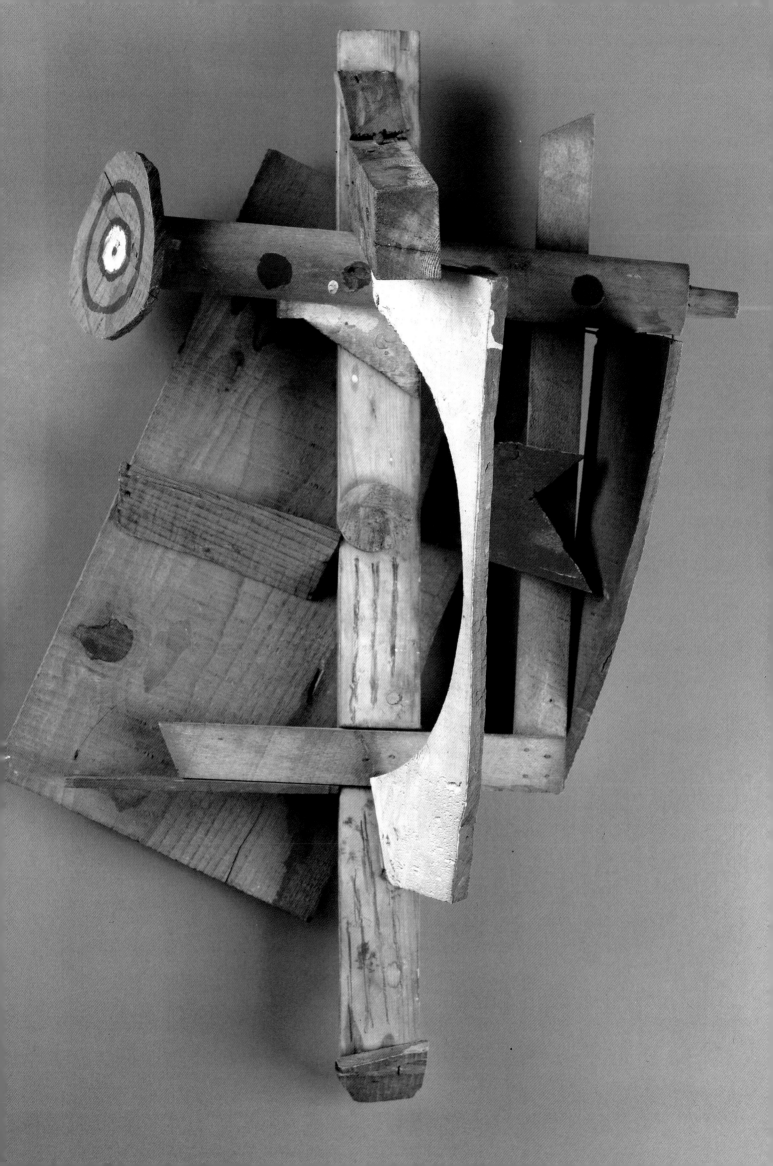

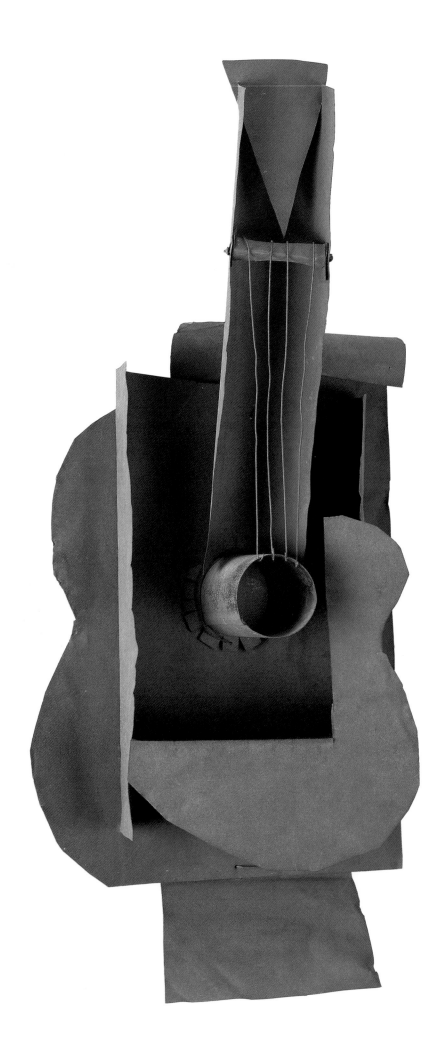

Guitar

1912, sheet metal and wire;
30½ x 13¾ x 7⅝ in.
(77.5 x 35 x 19.3 cm).
Gift of the artist, The Museum
of Modern Art, New York.
The touchstone to Picasso's
understanding of new re-
lationships between real
and painted forms remain-
ed sculpture. Here, the
constructed metal planes
invert sculpture's traditional
relationship between mass
and volume. This invers-
ion would come to have
important ramifications
in sculpture, as well as in
architecture and design.

Bread and Fruit Dish on a Table

1909, oil on canvas; 64⅝ x 52¼ in. (164 x 132.5 cm). Kunstmuseum, Basel.
The large-scale forms show the influence of Picasso's study
of the works of Cézanne, who argued that everything should
be reduced to volumetric shapes. Such simplifications are
precursors to the more complex works of Cubism proper.

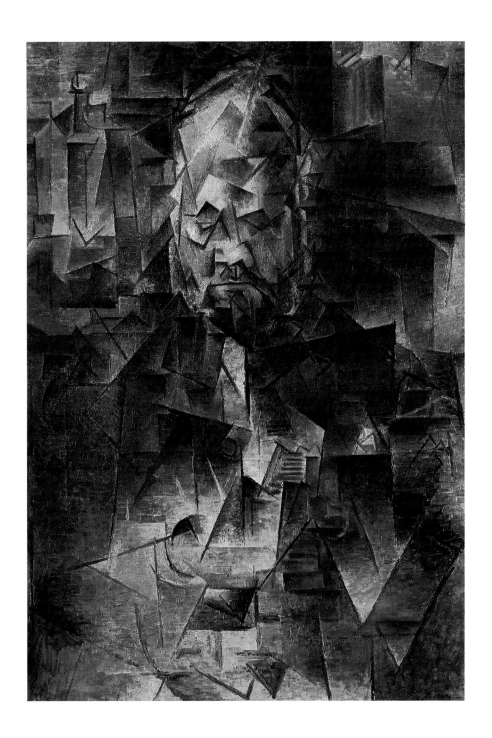

Portrait of Ambroise Vollard

1910, oil on canvas; 36¼ x 25⅝ in. (92 x 65 cm). The Pushkin State Museum of Fine Arts, Moscow.
The art dealer Vollard often stated that friends could not recognize
him from this portrait, but a four-year-old had no problem doing
so, shouting "That's Vollard." It was purchased by the Russian art
collector Sergei Shchukine, whom Matisse had introduced to Picasso.

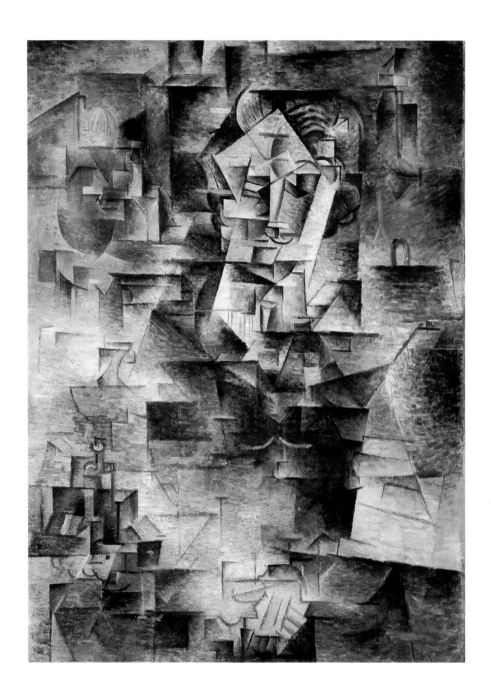

Portrait of Daniel-Henry Kahnweiler

1910, oil on canvas; 39⅝ x 25⅝ in. (100.6 x 72.8 cm). Gift of Mrs. Gilbert W. Chapman
in memory of Charles B. Goodspeed, The Art Institute of Chicago, Chicago.

The German art dealer Kahnweiler was a strong supporter of the Cubist movement and
his Paris gallery held many of the important exhibitions. His portrait is considered one of
the best examples of Analytic Cubism due to its evident interpenetration of space and form.

Geometric Composition: The Guitar

1913, oil on canvas mounted on wood;
34½ x 18¾ in. (87 x 47.5 cm).
Musée Picasso, Paris.

Neither Braque nor Picasso painted in a totally abstract manner, but they clearly thought in abstract terms. The only actual relation this composition has to the reality of an object is via its title. It was not unusual for Picasso to work at the same time in different but related directions.

Violin and Grapes

1912, oil on canvas; 20 x 24 in.
(50.6 x 61 cm). Mrs. David M. Levy Bequest,
The Museum of Modern Art, New York.

The greater size of the colored planes mark what is termed Synthetic Cubism, while the painted imitation of a wood grain plays with the interchange of the reality of the wooden guitar and *papier collés* ("glued papers").

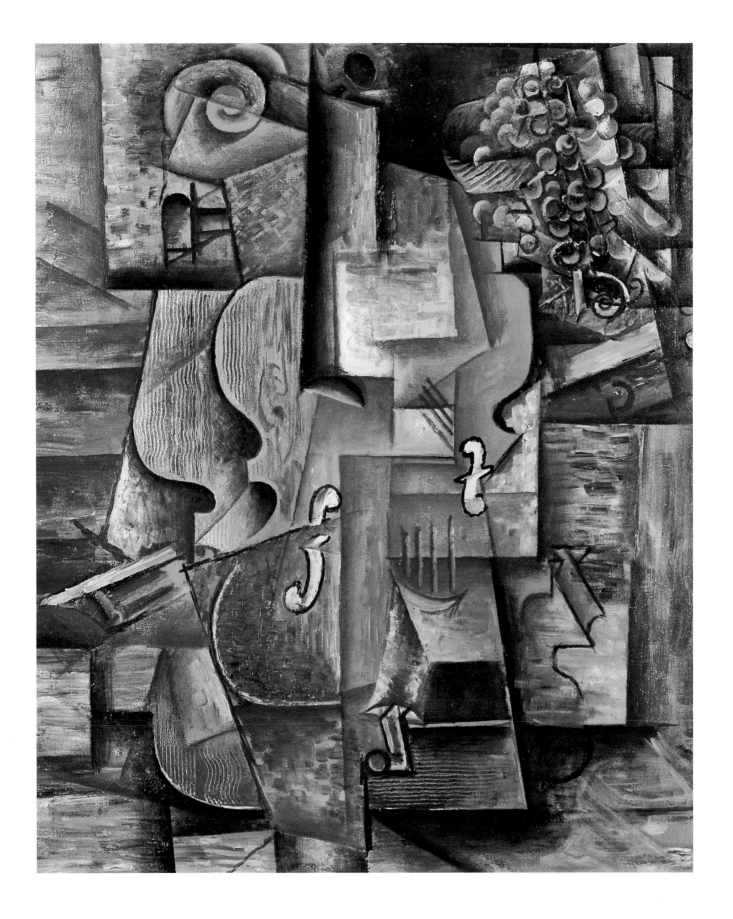

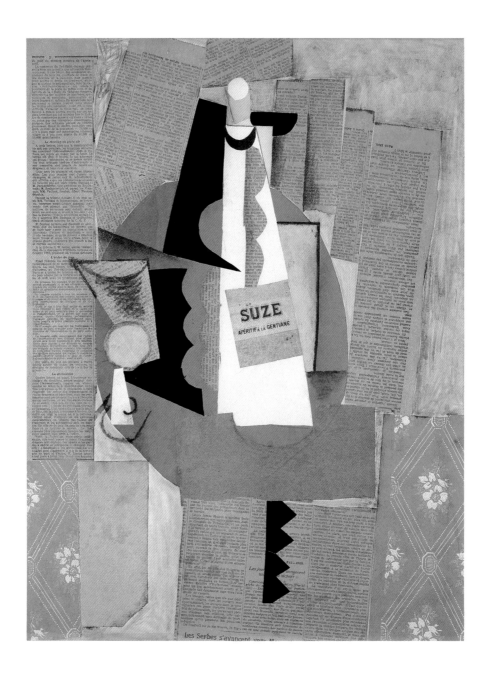

Bottle of Suze

1912, charcoal, gouache, and pasted paper; 25¼ x 19¾ in.
(64 x 50 cm). University purchase, Kende Sale Fund, 1946,
Washington University Art Gallery, St. Louis, Missouri.

Newspapers, labels, and wallpaper combine with drawing and
painting in more complex collages such as this work. In addition
to being crucial parts of the particular painting, the newspaper
articles often referred to contemporary events as well.

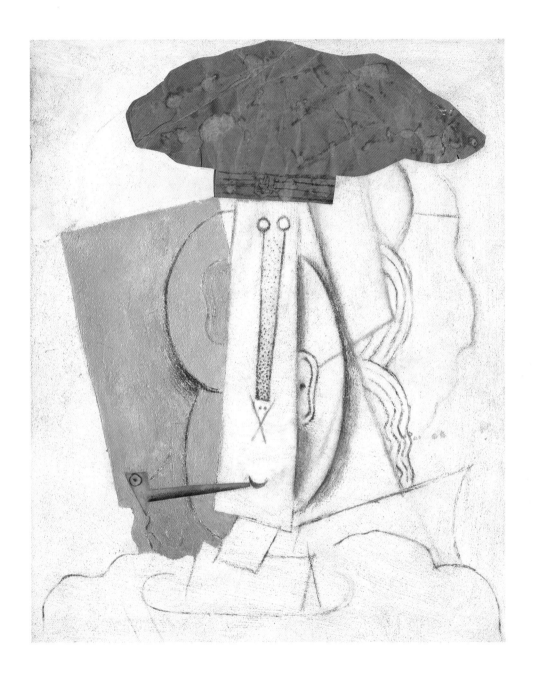

Student with a Pipe

1913, oil, charcoal, pasted paper, and sand on canvas; 28³/₄ x 23¹/₈ in. (73 x 58.7 cm).
The Museum of Modern Art, Nelson A. Rockefeller Bequest, New York.
Few artists understood more or applied better their
humor to art than did Picasso. He intuitively grasped the
kinship between the faculties of humor and creativity. The
use of sand here was a simple statement declaring that any
material could be made into art through creative application.

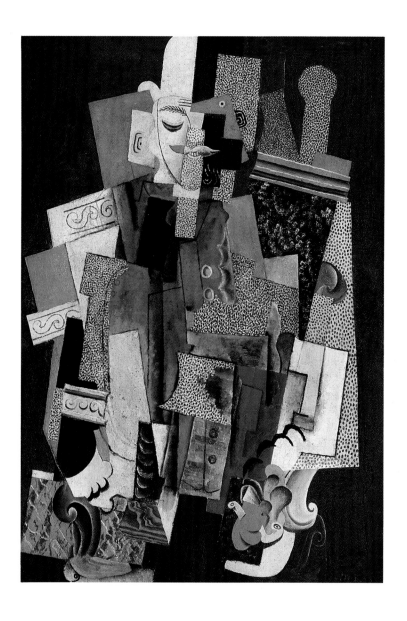

**Untitled (Man with
a Mustache, Buttoned
Vest, and Pipe, Seated
in an Armchair)**

*1915, oil on canvas; 51¼ x 35¼ in.
(130.2 x 89.5 cm). Gift of Mrs. Leigh
B. Block in memory of Albert D. Lasker,
The Art Institute of Chicago, Chicago.*
In spite of the gay feeling
generated by this so-called
Rococo Cubist painting,
at the time of its completion
France was at war, Braque
was wounded, and Eva,
Picasso's current lover,
was ill and soon to die.

Violin and Bottle on a Table

*1915–1916, construction of painted wood, tacks, string, and charcoal;
17⅞ x 16⅜ x 7½ in. (45.5 x 41.5 x 19 cm). Musée Picasso, Paris.*
The use of paint in the wooden relief sculptures became a
physical component visually equal to the wooden planes. The
assertion of the physical weight of color eventually became a
major component of twentieth-century architecture and design.

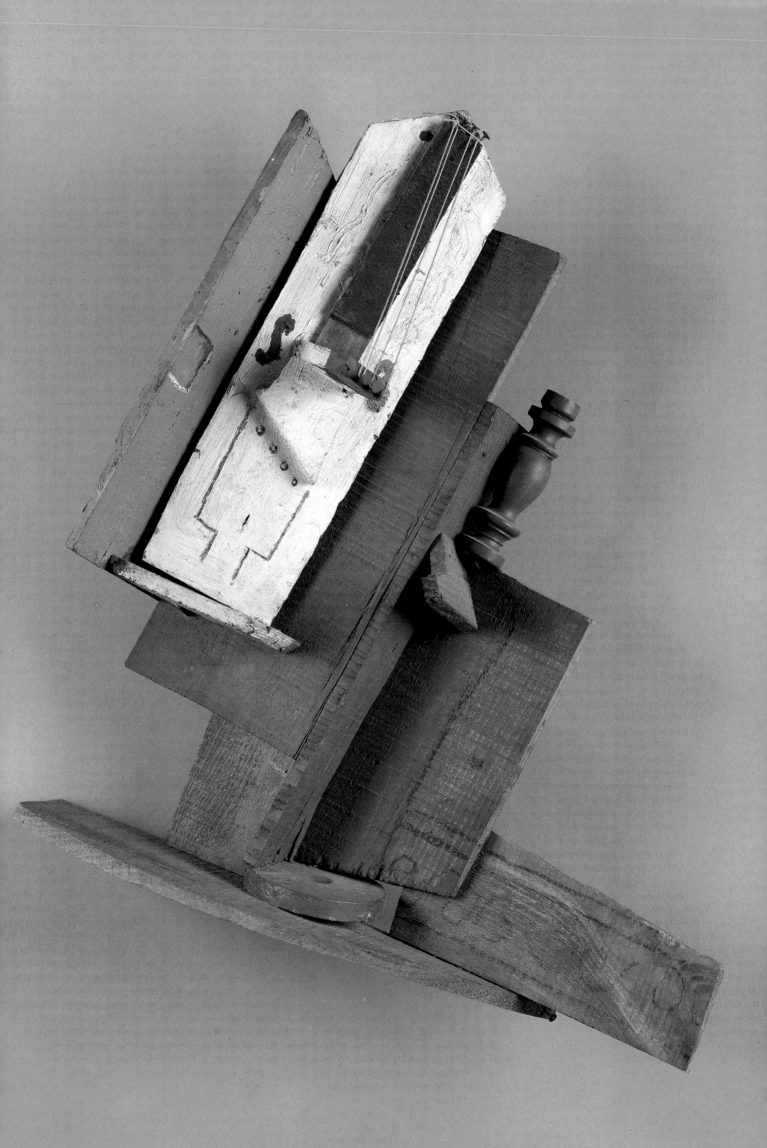

Woman in Spanish Costume (La Salchichona)

1917, oil on canvas; 45⅝ x 35⅛ in. (116 x 89 cm). Museo Picasso, Barcelona.

Composing over a drawn figure with small points of pure, intense
color was a technique adapted from the late ninteenth- and early
twentieth-century French Neo-Impressionists. The lack of formal
finish and the combination of techniques were made acceptable
previously in the works of Edgar Degas and Henri de Toulouse-Lautrec.

FROM HARLEQUIN TO MINOTAUR

Picasso had referred to his relationship with Georges Braque as a kind of "faithful" marriage, but when Braque returned from the great war in March of 1916 with a serious head wound he was a different person in a different world and unable to adjust to Picasso and his new place in it.

The end of the collaboration was apparently due in large measure to Braque's attitude but also to changes in his former colleague's life and direction. Much had changed. Picasso now lived the life of a financially successful and well known artist. Picasso and Eva Gonzalez, his companion since late 1911, had moved twice by the summer of 1913, from the bohemian quarters of Montmartre to arrive in the quarter of Paris on the left bank of the Seine known as Montparnasse, whose cafés were centers of Parisian artistic and intellectual life. Here he had a spacious studio, a maidservant, and had begun a more formalized style of life by the outbreak of the war in August of 1914.

Back to the Future

At first it seemed as if the war never existed for Picasso, who as a Spaniard was exempt from service, though many of his friends were off to fight. However, the challenging new style of Cubism became associated in much of the public's mind with the enemy (*les boches*) because of Picasso's foreigner status and his German patrons. But with the closing of the war's front lines toward Paris and the lingering illness and eventual death of Eva in December of 1915, Picasso opened a new front line of his own.

The founder of Cubism turned to naturalistic drawings and paintings that were considered a sell-out by the now numerous Cubists. What others considered a new artistic conservatism was for Picasso a continuation of his restlessness and a love of drawing since childhood. The precision and discipline in his drawing style was defended as a turn to the nineteenth-century master of linear contours, the French classicist J. A. D. Ingres. From 1915 to 1923 Picasso's line drawings constituted a "marvelous picture gallery" of the leading intellectuals within the orbit of Paris. Nor was he alone.

The post-war period of the entire European avant-garde, many originally associated with Fauvism or Cubism, generally sought solace in what has been described as a "call to order," with the return of figuration and naturalism becoming widespread. Despite the opinions of his critics, Picasso never abandoned Cubism but simply considered it one alternative never intended to invalidate more traditional forms of art. Indeed, much of his Cubist experiments were direct responses to long held problems in the history of art. Picasso never contrived to overturn history as much as to work within it in a more contemporary manner. His instinctive understanding of this challenge in addition to that side of his Spanish personality that was "traditional" were major factors in his success.

The severe, self-imposed restrictions of the Blue, Rose, and Cubist periods had demonstrated a personal discipline that could be interpreted as conservative. Yet the component parts in each of these phases were admixtures of ideas, old and new. Nor would it be unusual for Picasso to continue such combinations, even when his range moved beyond the limits of avant-gardism. For instance, the startling beauty of *Woman in Spanish Costume ("La Salchichona")* (1917) owes much to its Ingres-like realism through a concentration on contours seen in his Rose Period. However, the small points of pure color and increased textures used here were borrowed from the "pointillist" style of the French Neo-Impressionists and had made their appearance in the decorative or Rococo Cubism from 1914. Such mixtures coexisted with pure representational styles, as seen in the portrait of his new love and soon-to-be wife, *Olga Picasso in an Armchair* (1917), and the portrait of his son, Paulo, dressed as a harlequin (*Paulo as Harlequin*, 1924). Throughout this period he also continued his Cubist

Olga Picasso in an Armchair

1917, oil on canvas; 51¼ x 34⅝ in. (130 x 88 cm). Musée Picasso, Paris.
Picasso met his first wife, Olga, while she was a dancer
in the Russian Ballet company, for which he provided
numerous set and costume designs. The daughter
of a Russian general, they lived a life together quite
different from that of the artist's bohemian beginnings.

experiments through constructed sculptures, the har-
lequin series, and richer, more inventive variations,
such as found in *Mandolin and Guitar* of 1924 or the
1928 *Painter and Model.*

Picasso had also returned to an old love during the
war years, the theater. In 1916 he undertook the set
and costume designs for a new ballet titled *Parade*
composed by the modernist French writer and soon-
to-be film director Jean Cocteau. It was to be per-
formed by the well-known ballet company, the Ballets
Russes, under the direction of its impresario, Sergei
Diaghilev, with music by Erik Satie and choreography
by Léonide Massine. Its opening in wartime Paris in
May 1918 was greeted by insulting shouts from the
audience against the modernist "noise" of Cocteau

and Satie and Picasso's Cubist costumes, whose size
dwarfed the dancers, making the scale appear unreal.

Guillaume Apollinaire, the poet-defender of
Cubism, himself a wounded French war veteran who
commanded public respect, not only settled the
uproar on opening night but had written the program
introduction. In his description of the ballet he used
the word *surréalisme* (super realism) for the first time
to explain the strange conjunctions of sound, design,
and choreography. That mélange, he explained, was
to be the new spirit (*l'esprit nouveau*) of the post-war
era. Despite the public rejection and limited perfor-
mances of *Parade*, Apollinaire's announcement proved
correct. When the Surrealist movement formed in
Paris several years later the title, cacophony, and the
name Picasso were all absorbed.

Picasso's experiences with *Parade* led him to Rome
for the rehearsals where he met Olga Koklova, a
dancer with the company. Living together by 1917
and married in July 1918, life for the painter moved
toward the high society (*le haut-monde*) that Olga, the
daughter of a Russian general, expected and desired.
Already financially comfortable, this proved to be
another change in lifestyle for Picasso. Whether the
classical ambiance of Rome or the simplified volumes
of the figures in the ancient Roman wall paintings he
visited while in Italy had any impact is difficult to
assess. But a third, unexpected, and mostly unex-
plained style developed within this general time
frame, one dominated by large-scale figures and
referred to as a new form of "Mediterranean classi-
cism" or, more simply, as a period of "colossal" fig-
ures. Thus entering the 1920s Picasso's Cubist and
naturalistic art forms were joined by a new sense of
classicism. Once more, as was often the case with
Picasso, the changes ranged widely and ultimately
meant more than a change in style.

The large-scale figures of *The Three Women at the
Spring*, painted in the summer of 1921, recall the ear-
lier experiments made by Picasso from around 1905

Three Women at the Spring

*1921, oil on canvas; 80¼ x 68½ in. (203.9 x 174 cm). Gift of
Mr. and Mrs. Allan D. Emil, The Museum of Modern Art, New York.*
The monumental figures which appeared early in
Picasso's "neoclassic" phase were frequently referred
to as great sculptural friezes. In this painting, the
use of the term *classicism* refers to not only their
clothing but their sense of quietude and the
simplification of form through geometric volumes.

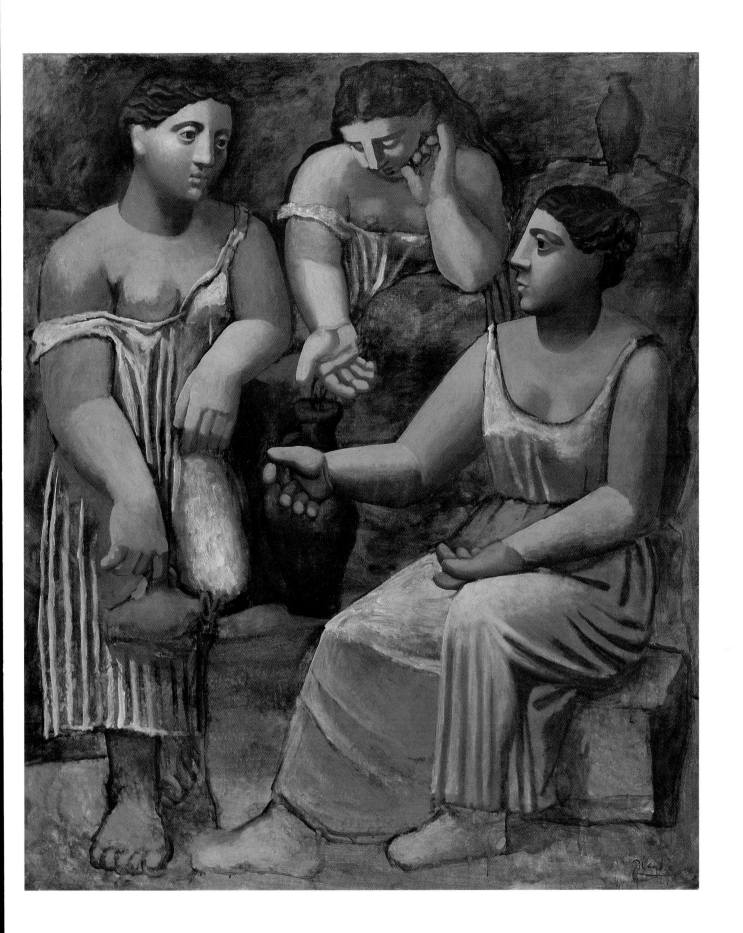

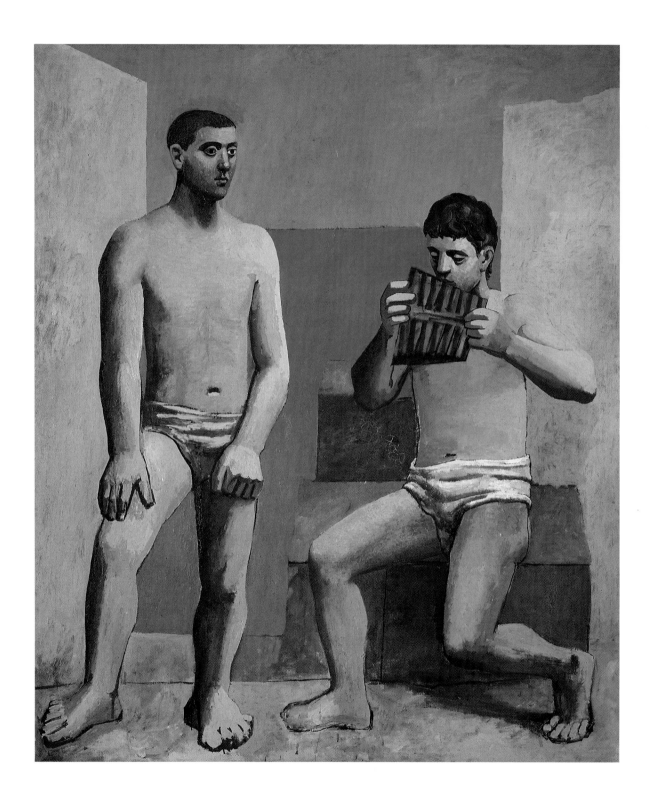

The Pipes of Pan

1923, oil on canvas; 80¾ x 68¾ in. (205 x 174.5 cm). Paris, Musée Picasso.
This work is part of the artist's neoclassic series and was painted at
Antibes in summer. Picasso felt he was more in touch with ancient
mythology when summering in the south of France by the sea.
The earlier geometric volumes have given way to a more naturalistic
handling of the bodies, locked in by a simplified, planar background.

that led up to *Les Demoiselles*. There is a basic naturalism here in the 1920s but the columnar volumes of their thick arms and necks and the masklike faces derived from African or "Negro" art. Their classicism is evidenced by the simple linen dresses and the stylistic reference to the now modern tradition of French classicism achieved through the simplification of forms.

Two years later the two youths in the 1923 *Pipes of Pan* are as thick and simplified as the women but more graceful, less geometric. The quietude here emerged from the reduction of the backdrop of beige walls and calm blue sea to large, flat planes of color. The tone of the scene was an absorption into a remote world of music as the pan pipes of classical times cast a meditative mood intended to evoke some vision of an archaic pastorale. The same qualities of large, sparse forms and introspective moods can be seen in other works from this period, but curiously the stylistic spell ends around 1925, to recur only periodically in later phases.

More important than style was Picasso's movement into the subject matter of myths. The painted figures evoked a quiet and generalized reference to the Graeco-Roman world of mythology. However, classical subjects taken from specific Greek and Roman myths occurred in his drawings and prints from 1920 onward, first developed in the south of France. In these worlds there was concentration on the horrific aspects of myth—of passions, rapes, and agonies.

The world of mythology was to eventually provide Picasso with a vehicle to explore the subterranean depths of the human psyche. A taste and perhaps a source is found in the final collaboration between Satie, Massine, and Picasso for the 1924 ballet *Mercure*, which was based on stories of Greek gods "spiced with mundane fantasy." It was not incidental that the founder of the Surrealist movement, André Breton, who considered ballet an unduly aristocratic art form, praised Picasso's designs. There was a darker, more psychological tone developing in Picasso's work that would soon merge (as did the Surrealists' work and the investigations of Sigmund Freud) with the mythic.

The maturation of Synthetic Cubism seen in both versions of *The Three Musicians* three years earlier had simultaneously introduced an unspecified note of something more ominous. By 1925 *The Dance* used flat flesh-toned figures high-stepping in a shallow space against equally flat planes of interior walls and windows—a basic late Cubist vocabulary of forms. However, the ostensible gaiety was offset by the grotesquerie of the figure on the viewer's left. The spiky blond hair and sharpened teeth set in a gaped mouth against red lips strikes a sinister tone that washes over the rest of the work. This was not as

The Dance

1925, oil on canvas; 84⅝ x 55⅞ in. (215 x 142 cm). The Tate Gallery, London.
The Surrealist artists published this painting in one of their journals as soon as the work had been completed. To them Picasso painted a form of Surrealism within Cubism, and for Picasso the work signaled a marked change in tone toward the horrific.

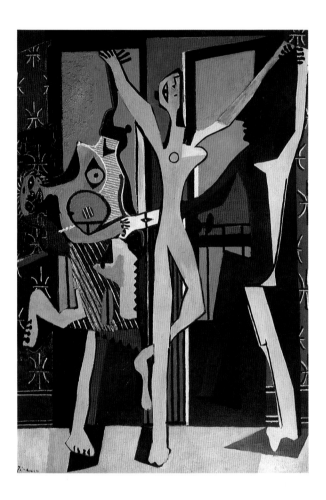

Henri Matisse would have his classical and joyous idylls of music and dance. It is a rude, even terrorist separation from Picasso's more lyrical and classical works of the same time.

More than one observer has noted the important turning point for the painter marked by *The Dance*, likening it to a more frightening version of *Les Demoiselles*. That same summer Picasso proved this turning point with *The Embrace*, considered even more aggressive in spirit. With these few works the call to order ended and a reign of terror began. Yet if it was terror, it was certainly productive. The late 1920s and 1930s provided a rich outburst of innovation in painting and sculpture. Surrealism, the new Parisian art movement soon to be international in scope, was likely less cause and more a parallel spirit of the times.

**Nude in
an Armchair**

1929, oil on canvas;
76¾ x 51¼ in.
(195 x 130 cm).
Musée Picasso, Paris.
The nude is apparently a reformulation, or "metamorphosis" as Picasso favored, of the tradition of luxurous female sensuality, developed in the Renaissance and repeated by academic painters as well as by Picasso, in earlier works. Contrary to the tradition, there is here a strong sense of perversion.

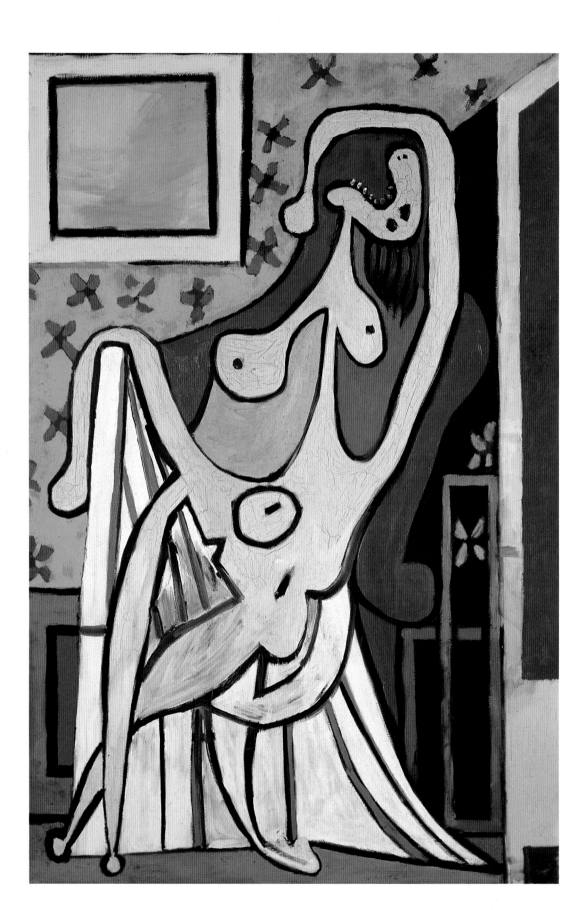

Surrealism

Picasso was fully aware of the international developments in more radical art forms. His status was such that the younger radical movements generally accommodated him rather than vice versa because he symbolized so much to them on personal and public levels. His works were featured illustrations in the first and only publication of the 1916 Dada journal (*Cabaret Voltaire*) published in Zürich. He knew the Paris Dadaists and their raillery against traditional art forms and attended their "rowdy manifestations" in reaction to the general absurdity of the war and what they considered an over rationalized world. While much of the Dada protest against rationality was directed to the Cubist movement, Picasso was publicly exempted.

By 1923 to 1925 Picasso had met André Breton and been adopted by the Surrealists, who first followed the Dadaist nihilism then emerged from it with many of the former Dadaists members and their own more poetic and psychological program of ideas. Picasso contributed abstract drawings to the second issue of the Surrealist journal (*La Révolution surréaliste*) and by the fourth number Breton included the first reproduction of *Les Demoiselles*, some of Picasso's collages, and the new 1925 painting, *The Dance*. In that issue

Breton wrote: "We claim him as one of ours. . . . Surrealism . . . has but to pass where Picasso has already passed, and where he will pass in the future." Although they mistakenly condensed much of Picasso's development, they recognized the sense of terror in his painting and correlated it with the Surrealists' strange call for a "compulsive beauty," an extension of the Symbolists' decadent beauty already familiar to Picasso, but expressed in a more wrenching and psychological manner.

The Surrealists welcomed poets and painters who stressed the role of the unconscious and the ways the subterranean part of the human psyche manifested itself in dreams, fantasy, and spontaneous or automatic acts of mind and hand. In this realm Picasso, always happiest among poets, found a new home and vitality. Their ideas fueled him and they provided him with one of his most powerful visual metaphors, the minotaur. The Surrealists in turn accepted Picasso for what they believed he was. In their terms the painter was "Surrealism in Cubism" and his works from this period verified their accuracy.

The 1929 *Nude in an Armchair* has an interior with the linear, flat, and interlocking Cubist planes of color. The nude woman is a crudely drawn and roughly painted form of distorted body parts, who

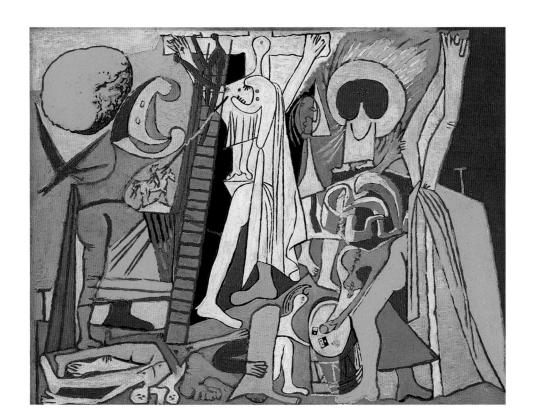

Crucifixion

1930, oil on wood; 19³/₄ x 25⁷/₈ in. (50 x 65.5 cm). Musée Picasso, Paris.

Picasso's abilities with bright, harsh colors in combination with Cubist planes, Surrealist curves, and fantastic creatures imposed a tortured sensibility on any painted figure or scene. In this work, one feels the agony often associated with the death of the Christ figure, though in quite modern, symbolic terms of style.

Seated Bather

1930, oil on canvas; 64½ x 51 in. (163.2 x 129.5 cm).

Mrs. Simon Guggenheim Fund, The Museum of Modern Art, New York.

Picasso's final metamorphosis of the classical tradition was achieved with figures that reminded observers of petrified bones and insectlike monstrosities. Here the traditional female nude beach bather, symbol of the sensuality of the Mediterranean tradition, has become monstrous.

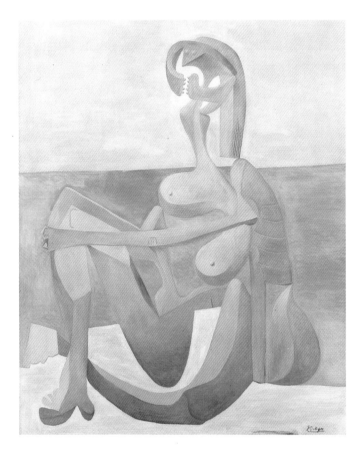

tips back a tooth-filled face in what is either a grin or scream. She openly mocks the pose of sensuous luxury engendered by hundreds of years of tradition of the nude female form with upraised arm, as displayed in Picasso's 1904 drawing *Meditation (Contemplation)*. Her metamorphosis was a theme he had been exploring in a series of small sculptures of bathers.

His *Crucifixion* of 1930 uses the bright colors and basic Cubist vocabulary to present a similar figure, one assumed to be Christ, draped from the cross while fantastic creatures throw dice for his cloak. There is nothing religious here, only torment. Again the central figure from *Nude in an Armchair* is metamorphosed at the beach in *Seated Bather*. Here

Picasso rendered the body parts in a combination of curvilinear lines more typical of Surrealist drawings but modified through Cubist shaded planes to look like bones. The moment of quiet beauty inherent in a sun-drenched bathing scene was made hideous by the separation of body parts and the insectlike mandibles that substitute for jaws. The mantislike head perhaps derived from a favored Surrealist symbol has blatant references to the devouring of her mate during sex. Picasso's Mediterranean classicism is replaced here by the petrified bones of a female monster.

The Minotaur

The Surrealists had adopted the mythological image of the minotaur as their chief symbol. Half man, half beast, the legendary figure from the island of Crete was said to devour human sacrifices made to it, and had come down through the ages as a creature of passion. The Surrealists seemed to emphasize the minotaur emblematically, as a marker for the arena of human subconscious where passions ruled and where rationality was accepted as an intruder which blocked a full articulation of the world.

Picasso used the minotaur in sketches from the late 1920s but in the 1930s and for the rest of his life he accepted the creature as a replacement for the harlequin, a new surrogate self-portrait. It is tempting and likely accurate to read in this figure's brute savagery and appetites a metaphor for Picasso's self-image of passionate creativity. No one reading is correct, however. The meaning of the minotaur changed in each rendering, seldom understood as a literal symbol.

In May of 1933 Picasso designed the cover of the new Surrealist journal titled *Minotaure*. The collage featured the minotaur as a line drawing of a powerful body holding a Roman short sword. The Surrealist battle seems imminent. But surrounding it with found objects such as ribbon, paper doily, linen leaves, and silver foil tacked to corrugated cardboard in the shape of a window was a surprise. They belie the savagery of

Maquette, for the cover of *Minotaure*

1933, collage of pencil on paper, corrugated cardboard, silver foil, ribbon, wallpaper painted with gold paint and gouache, paper doily, burnt linen leaves, tacks, and charcoal on wood; 19⅛ x 16⅛ in. (48.5 x 41 cm). Gift of Mr. and Mrs. Alexandre P. Rosenberg, The Museum of Modern Art, New York.

Designed for the cover of the new Surrealist journal *Minotaure*, this work depicts the well known mythic figure of the minotaur, a loaded symbol for the artist which also served him through a number of levels of meaning.

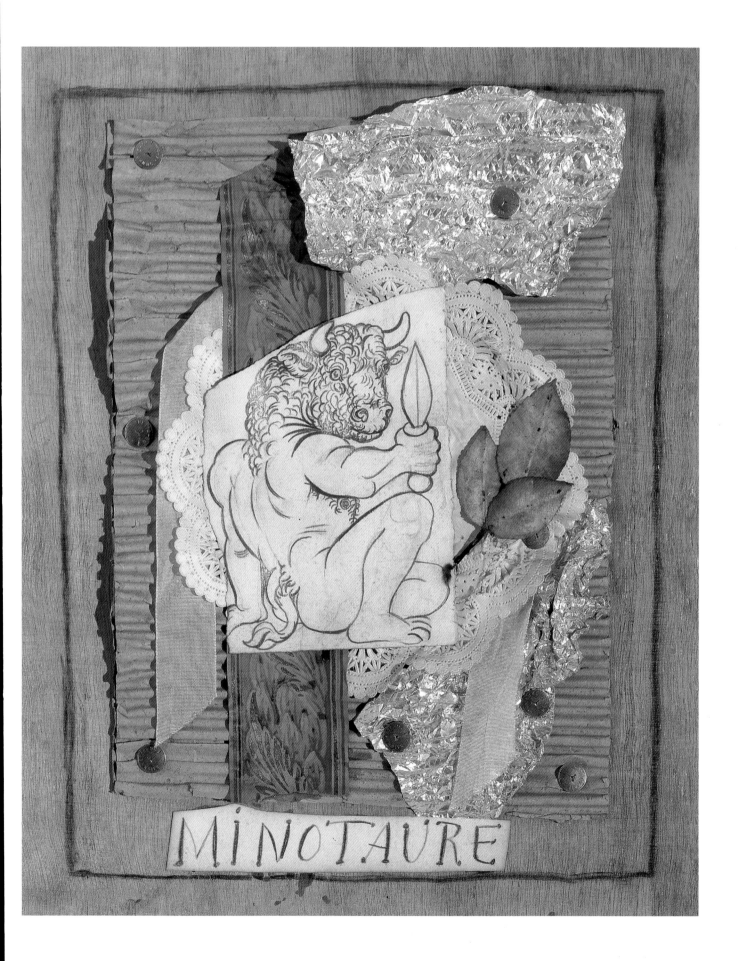

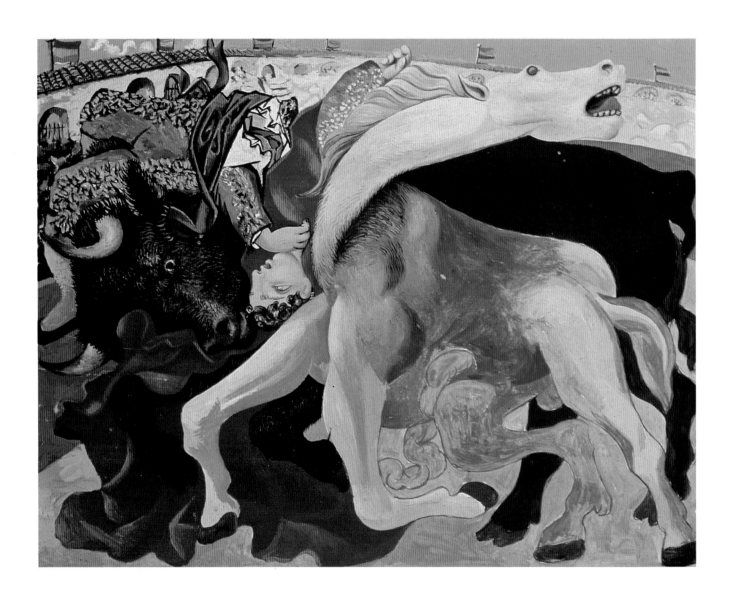

Bullfight: Death of the Toreador

1933, oil on wood; 12¼ x 15⅞ in. (31.2 x 40.3 cm). Musée Picasso, Paris.
At the age of seven Picasso was attending bullfights
with his father, while his earliest painting was of a
Picador. The bullfight remained a personal passion
which provided a staging ground for elemental violence in
his paintings. Here, both toreador and horse die in agony.

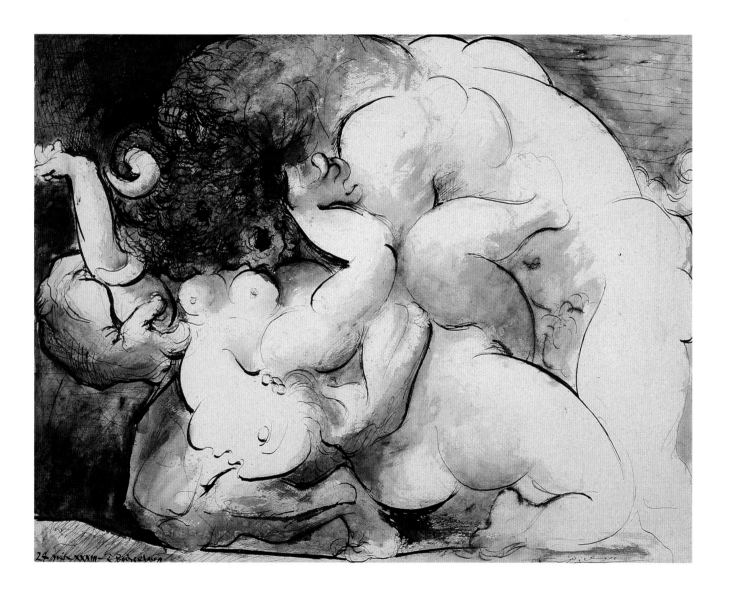

Minotaur and Nude

1933, ink on blue paper; 18½ x 24½ in. (47 x 62 cm).

Gift of Margaret Blake, The Art Institute of Chicago, Chicago.

One of the incarnations of the minotaur was the
personification of animal passion. Although this series
of drawings has been variously titled to include a battle with
the mythic Amazons, the primary emotion appears to be lust.

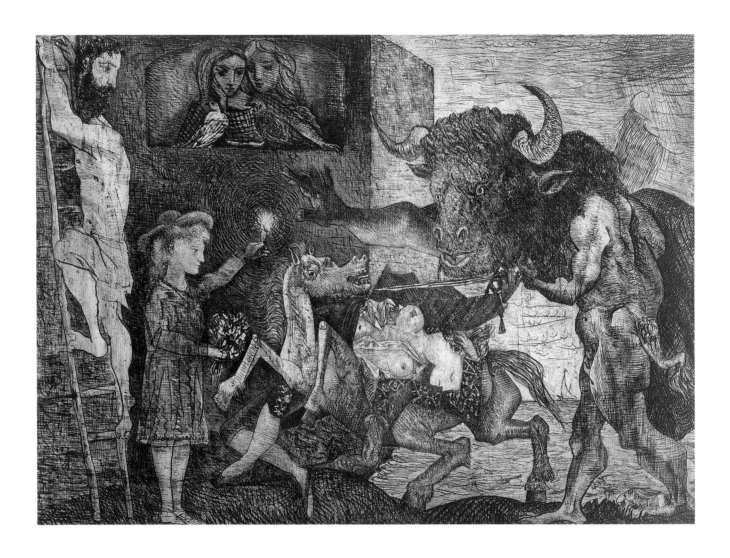

Minotauromachy (7th state)

*1935, etching; 19½ x 27⅜ in. (49.6 x 69.6 cm). Abbey Aldrich
Rockefeller Fund. The Museum of Modern Art, New York.*
The themes of minotaur and bullfight recombine
in Picasso's most ambitious print to date. Here
the Minotaur seems the wounded demi-god,
a figure of pity, guided along the shoreline by
the light of a girl-child, at the same time a dead,
half-naked woman matador is carried across a
horse. This came at a time when the pregnancy
of Marie-Thérèse, his girl-child mistress,
was helping end Picasso's marriage with Olga.

a creature, as the eyes of the minotaur look out in a clear and somehow human fashion.

In a series of etchings from this time period Picasso had the minotaur befriended, then led by an innocent young girl, eventually to die pathetic and alone (*Minotauromachy*, 1935). Yet in drawings of the same year (*Minotaure and Nude*) the minotaur's physical strength is combined with a violent sexual appetite. Although the specific meanings range widely the minotaur had surely become a major protagonist in the visual and perhaps personal life of the artist.

Some sense of the personal sources for Picasso's emblematic translation of the world in which he lived is seen in the many versions of "Bullfights" in the 1930s. Here, bulls, horses, and humans, male and female, lock in battle and death throes which carry all the savage power of his screaming figures and the animal passion of the Minotaur series. The bullfights of his youth (and which he attended all his life) are here in grisly summation. The French poet and writer Georges Bataille had drawn analogies in a 1930 essay between Picasso's passion for bullfights and primitive themes of sun worship and bull rituals. Picasso had always surrounded himself with animals, keeping many in his various homes, and they appeared consistently in his paintings, sculptures, and prints in a wide range of meanings, from humorous to base passions. It was Picasso's singular ability to call into existence the elements and meanings necessary at a crucial time that led to one of the great masterworks of the twentieth century, a work with which the name and personality of Picasso is indelibly marked: *Guernica*.

Guernica

The worldview of the brutality engendered by the mythic portrayals of the unconscious are often considered preludes to Picasso's major painting of the 1930s. Like so much visual art and writing worldwide, the painting was inspired by the Spanish Civil War, specifically the destruction of the Basque town of Guernica by German bombers in the service of Spanish fascists on April 26, 1937. Picasso was an active supporter of the loyalists in his homeland, a fact recognized when they appointed him Director of the Prado Museum in 1936. The Republican government of Spain called on him to represent them and Picasso in turn called upon the terror and pity he had pictured in his own works since 1925 to not only transmit those qualities to others of his time but to encapsulate the horrors of war for the entire twentieth century. Few paintings can summarize such a vast segment of the human character. *Guernica* still stands today as an icon, a modern history painting in a period that frequently turns its back on history.

It was executed in virtually one month's time, between May and June of 1937, for the Spanish Pavilion of the Paris World's Fair. A huge canvas, measuring 11 1/2 by 25 1/2 feet (3.5 x 7.8 meters), it was painted bereft of color, using stark blacks, whites, and grays. At center is the agonized death of his horse from the bullfights, likely representing the loyal people of Spain. Screaming women from the painter's Surrealist lexicon flank the scene left and right, while a horned bull with the head of the minotaur bellows in the left background. The fragmented and decapitated body of a figure is thrown across the foreground, the broken Roman short sword still held in a dismembered hand. Women with rounded profile faces and both eyes on one side of the head, also part of his vocabulary developed in the 1930s, sweep in from the viewer's right. All exist in the collapsed space of a basic Cubist composition. Each part had been seen before but nothing can account for the new totality. The painting has long been recognized as the most powerful application of Expression through Cubism ever created. It was also prescient. The devastation of World War II was not long off.

The great canvas was the star attraction of the Spanish Pavilion. Other Spanish artists such as Joan Miró, Alberto Sánchez, and Julio Gonzalez also made contributions. So strongly did Picasso feel regarding the domination of his homeland by the victorious fascists in 1939 that he refused entry of the canvas into Spain until such time as Spain would become a democracy. After the death of General Franco in 1975 and under the guidance of an enlightened monarchy Spain enacted universal suffrage in 1977 and a new democratic consitution in 1978. The Museum of Modern Art in New York happily lost one of its great treasures.

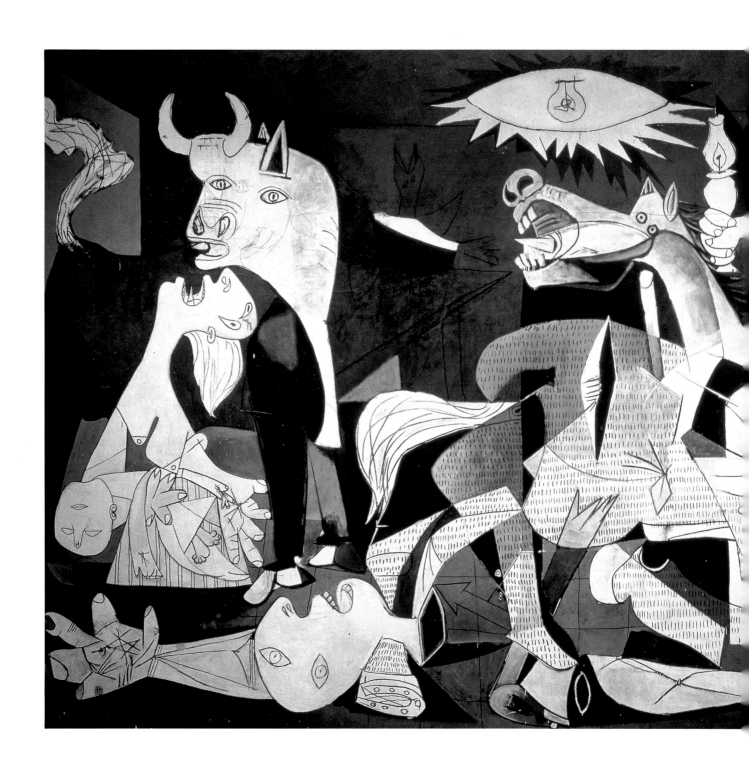

Guernica

1937, oil on canvas; 11 ft. 5½ in. x 25 ft. 5¾ in. (349.3 x 776.6 cm). Museo Nacional Centro de Arte Reina Sofía, Madrid.
History paintings are generally considered part of the past in which academic painting
reigned, but Picasso was able to update this tradition by providing a modern grammar and
syntax for age-old atrocities. His celebrated depiction of the Spanish Civil War here became
an international symbol for the hostilities of war and a rallying point for those who opposed it.

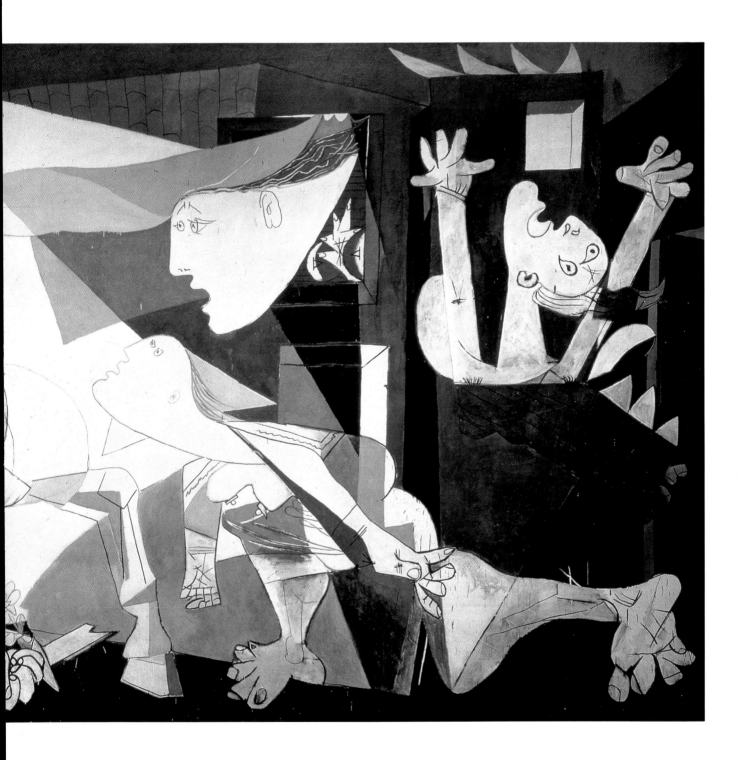

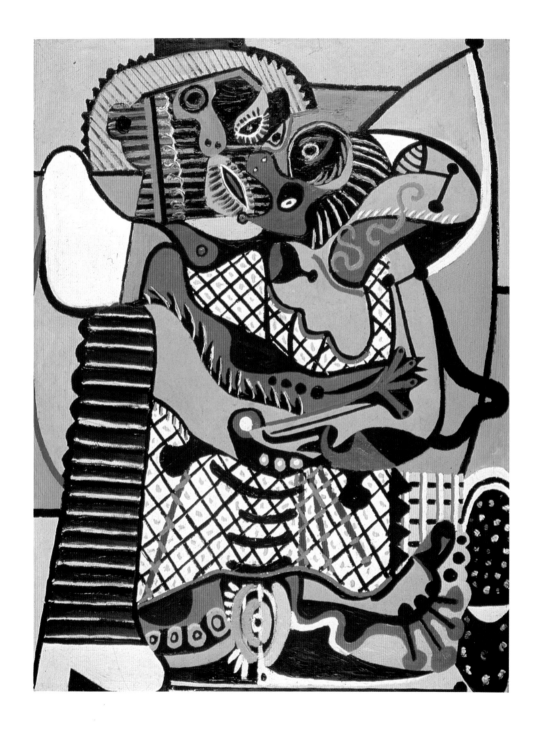

The Embrace

1925, oil on canvas; 51¼ x 38⅛ in. (130 x 97 cm). Musée Picasso, Paris.
This canvas is considered by some, along with
The Dance, as the beginning of a more violent,
psychological approach by the artist toward his subjects.
Gone are the endearing family moments of the early
1920s, replaced by more primal representations of lust.

The Many Lives of Picasso

As with his art so too had changes continued in Picasso's life. Olga bore Picasso's first son, Paulo, in 1921 but by 1925 the marriage was strained. Many have suggested that the ominous expressionism and the series of voracious women developed in paintings like *The Dance* and *The Embrace* were a direct result of the tension between the two.

In January of 1927 he introduced himself to seventeen-year-old Marie-Thérèse Walter and offered to paint her portrait with the now famous remark: "I am Picasso." She had never heard of him but six months later they were lovers. She was Picasso's secret, whose image appeared frequently in his works, but with the first officially named portrait of her five years off. Barely a summer passed which Picasso did not spend near the sea and in the summer of 1928 with his wife and son in Brittany he secretly kept Marie-Thérèse nearby. By the winter of 1930 he had installed Marie-Thérèse on the same street, the rue La Boëtie, as his family, only a few doors away.

That same year, in June, he purchased a home in the country forty miles (64 kilometers) outside Paris, the château de Boisgeloup, which became a center for his art work with the barn converted in 1931 into a sculptor's studio. He had learned to weld in 1928 under the guidance of an old friend from Barcelona, Julio Gonzalez, and Gonzalez became a frequent resident at Boisgeloup.

This was a period of happiness in Picasso's life and one of increased fame. An exhibition of his work had opened in New York City at the Museum of Modern Art in 1929, with major retrospective exhibitions, first in London in 1931 and a year later in Paris. The Paris exhibit traveled to Zürich, where it was not well received, and Carl Jung wrote an essay concluding that Picasso's style of fractured lines and forms revealed an interior schizophrenic personality of "psychic faults." Yet at least one phase of Picasso's art deeply reflected his contentment with Marie-Thérèse through a culmination of figure studies of women sleeping initiated in early 1932.

The *Sleeping Nude* employs the curvilinear line Picasso had developed from the Surrealist's biomorphic forms. They had used such rounded forms to express a primordial and psychic equation with nature. Picasso was more succinct. The sensuosity of Maria-Thérèse's body rendered through the curved forms was an open testament to the artist's sexual

Sleeping Nude

1932, oil on canvas;
51¼ x 63⅜ in. (130 x 161 cm).
Musée Picasso, Paris.
In the midst of Picasso's more terroristic portrayals of the female form came luxurious and sensual biomorphic paintings. There is an open eroticism in the curvilinear qualities and bright colors in his long series of works inspired by his relation with Marie-Thérèse.

Dora Maar Seated

1937, oil on canvas; 36¼ x 25⅝ in. (92 x 65 cm). Musée Picasso, Paris.
The style and coloration in this painting captures something of the personality of Picasso's new lover, the subject of the portrait. Picasso generally reserved a Cubist style for her.

pleasure. Typically, the painter was also as capable of rendering the enigmatic as the Surrealists, and showed it in what is considered a masterwork of the 1930s, the *Girl Before a Mirror*.

Again the central theme is the voluptuous body of Marie-Thérèse, rendered in rounded organic forms, but the narrative seems a modern psychological inversion of the old theme of vanity. An individual's reflection in a mirror in the history of art often signaled a misdirected concentration on physical materials and pleasure. Frequently it was death that stared back, but this reflection was clearly a woman. Was it an introspective portrait of his lover, a summation of

the mystery and prophecy Picasso found in women, or some cautionary self-reflection upon the artist's own pleasures?

His sense of pleasure ended abruptly when in 1935 Marie-Thérèse's pregnancy became public knowledge and Olga removed herself with their son to a hotel. Jaime Sabartés, a friend whose portrait Picasso frequently drew in the Symbolist days of Barcelona, agreed to move in with the troubled painter to handle his business affairs and recorded the moodiness that Picasso lived under for several years without his wife. Picasso, likely the most prolific artist of the twentieth century, stopped painting for almost a year. He later reflected on this period as the worst time of his life despite the fact that Marie-Thérèse gave birth to their daughter in October 1935. She was named after Picasso's young sister who had died as a child, Maria de la Concepcíon, called Maïa or Maya within the family. Although he contemplated divorce and accepted care of his daughter, if not legal lineage, Picasso never married Marie-Thérèse. Nor would he be content to remain alone.

While staying in a small village near Cannes in the late summer of 1937, where he was surrounded by friends, he entertained the daughter of a Yugoslav architect whom he had met earlier and known from Surrealist circles. Dora Maar (née Markovitch) was a photographer and Picasso invited her to photograph his studio. She soon became the fourth prominent woman in his life. She spoke fluent Spanish and was an intimate in the art world. The liveliness of her personality is seen in a 1937 portrait (*Dora Maar Seated*), whose sharp features are enhanced by a Cubist style and bright colors. After having photographed Picasso's making of *Guernica* her portrait appeared in a series of famous paintings. The angular, sharp planes and tear-stricken pose of *Weeping Woman* pictured Dora Maar in the more anguished style of *Guernica*, something Picasso wrestled with for many months following completion of the heroic mural.

Girl Before a Mirror

1932, oil on canvas; 64 x 51¼ in. (162.3 x 130.2 cm). Gift of Mrs. Simon Guggenheim, The Museum of Modern Art, New York.
Considered a masterwork of the 1930s, the exact meaning of this painting remains enigmatic but likely owes something to the influence of the Surrealist emphasis on the dream state, as well as on earlier "vanity" themes where death looks out from a mirror.

The Early War Years

By September of 1938 the ominous signs of war appeared once again. One year later Hitler marched into Prague while Franco consolidated his hold on Spain. At the same time *Guernica* was on tour, first in London and then the United States, to raise money for the Spanish resistance while serving as visual testimony for the atrocities of war in general to an international public.

The summer of 1939 Picasso spent in the idylls of southern France, as was his habit, at Antibes with Dora Maar. *Night Fishing at Antibes* was based on scenes observed in evening strolls with Maar. Fishermen spear fish by night lights while Dora and Jacqueline Lamba, the wife of André Breton, stand to the side watching as in a dreamscape. That same August, guns were set up along the French beaches; Germany invaded Poland in early September. With England and France declaring war Picasso retired to Royan, a town on the Atlantic Ocean near the city of

Night Fishing at Antibes

1939, oil on canvas; 81 x 136 in.
(205.7 x 345.4 cm). Mrs. Simon Guggenheim
Fund, The Museum of Modern Art, New York.
As guns of war were placed on the beaches of France, Picasso was able to find some solace and beauty in night strolls with Dora Maar along the summer coastline, watching the local fisherman use lights to attract fish.

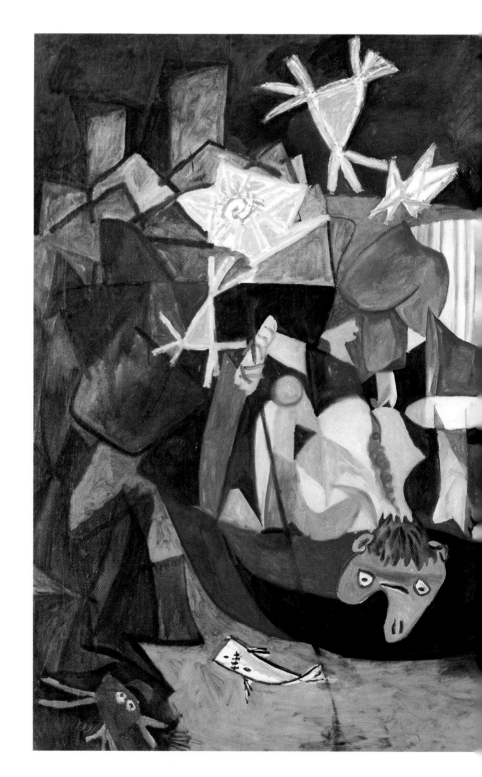

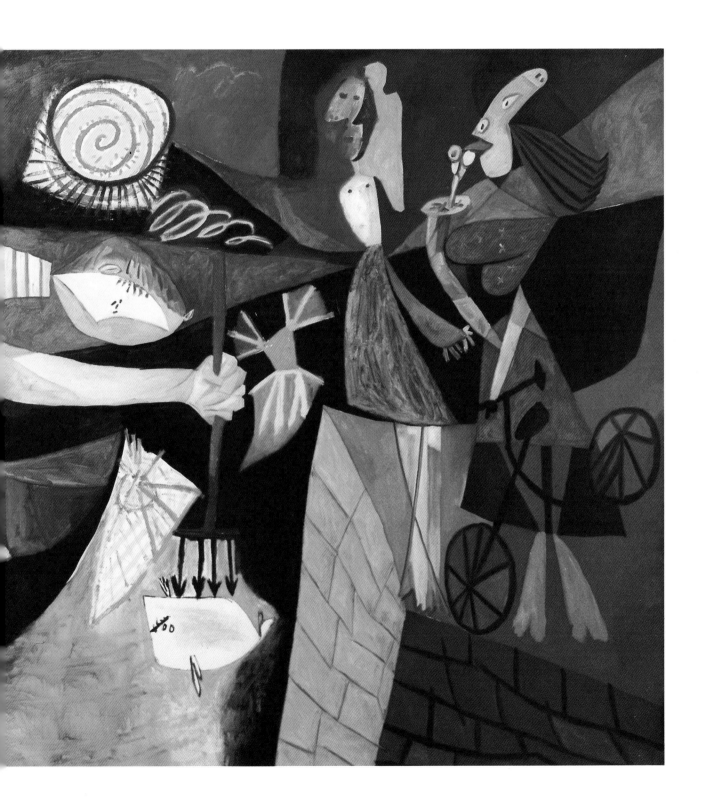

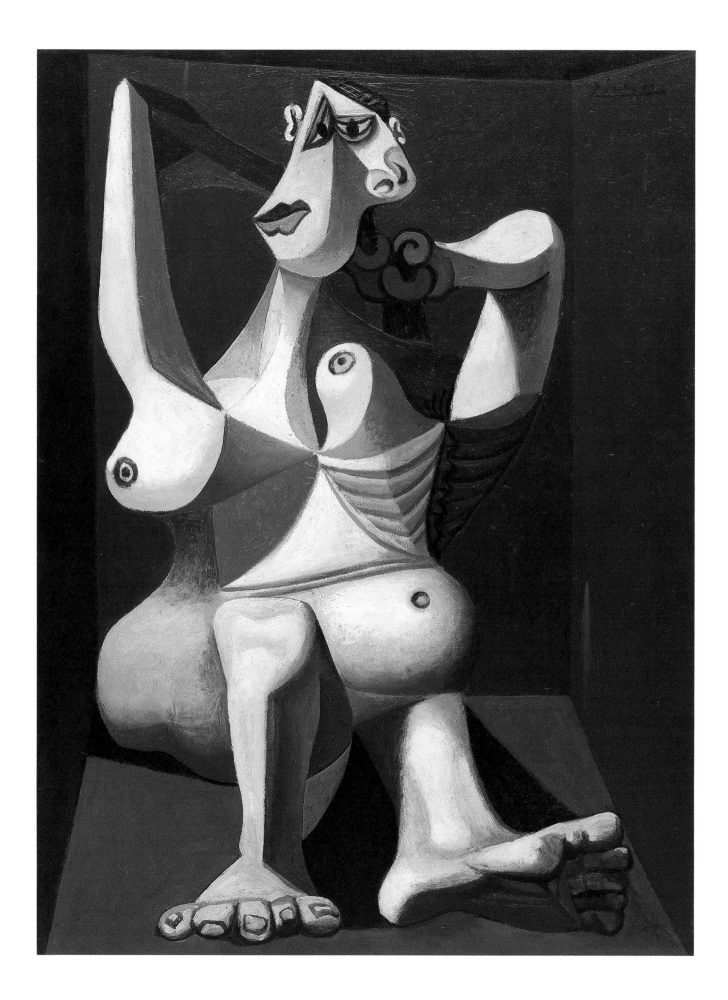

Bordeaux. The installation of Marie-Thérèse and Maïa nearby naturally produced numerous problems within his relationships. He remained here with month-long visits to Paris for art supplies and to work while maintaining his contacts.

Many of his friends were mobilized, including the Surrealists Breton, Paul Eluard, and Louis Aragon, at a time when he painted *Woman Dressing Her Hair*, once again combining Cubist and Surrealist vocabularies. On one such trip in May of 1940 he left Paris just ahead of the German occupation. With a French Armistice signed in June, German troops were garrisoned in Royan. Uncomfortable with their presence he returned to Paris with Maar, where he finished *Woman Dressing Her Hair*.

Sculpture

In Paris Picasso's collection was confiscated by the Nazis and his Boisgeloup studio made unavailable to him. Despite offers to live abroad he remained in Paris, changing his living quarters to the rue de Grande-Augustins for the duration of the war, and setting up a sculpture studio within it. In the spring of 1941 he was able to move Marie-Thérèse and Maïa back to Paris from Royan, and despite the Nazi restriction on the use of bronze (it was declared to be a needed war material), began casting bronze sculptures surreptitiously at night. With metal scarce he worked in plaster and began using found objects, later to be cast in bronze. This was an approach he had been employing for some time.

Picasso had returned to sculpture in 1928, creating his first three-dimensional work since 1914, derived from his Surrealist paintings of women on the beach. While he remained dedicated to the concept of meta-

morphosis, altering one thing into another, his means changed rather dramatically. At this point he renewed his acquaintance in Paris with Julio Gonzalez, whom he had first met in Barcelona in 1902. Throughout 1928 and 1929 he learned welding at Gonzalez's shop, which specialized in decorative iron work, and began to develop a new direction in his sculpture, one which followed the lead of his Spanish colleague.

Gonzalez had been experimenting with relief sculpture cut or incised from flat sheets of metal and had made Cubist masks and figures of open-work construction. His directly welded iron figures were of an open and linear structure which reduced solids into contour lines that defined voids rather than solids. The works were unprecedented but had developed from a basic Cubist syntax Picasso well understood. With his attention directed toward this different technique, direct metal sculpture became a serious concern in modern art and continues to this day.

Picasso's large-scale *Woman in a Garden*, completed in 1930, utilized thin lines and planes of welded wrought iron (later cast in bronze) to give a sense of delight to both the woman and the garden trees. This irrepressible humor and sense of fantasy moved Picasso quickly from straight metal work into combinations with found objects, something he had previously established with the 1914 *Glass of Absinth*.

In his 1930–31 *Head of a Woman* Picasso used painted iron with sheet metal, springs, and kitchen colanders to form the head. He spoke on more than one occasion of his striving to remain childlike in his drawing and thinking. The result is a child's delight in the element of fantasy that continued to operate throughout his life and, by extension, in twentieth-century sculpture. There is no better example in modern sculpture than Picasso's *Head of a Bull* (1943). Assembled from the handlebars and seat of a discarded bicycle found during the war, it is a delightful metamorphosis of his beloved bulls, and even perhaps the minotaur.

In an earlier published interview Picasso had rejected the concept of research in art, proclaiming that the

Woman Dressing Her Hair

1940, oil on canvas; 51¼ x 38¼ in. (130 x 97 cm).

The Museum of Modern Art, New York.

Another metamorphosis of the neoclassical nudes Picasso painted in the mid-1920s, this large work is a major composition completed after the German invasion of France and the beginning of World War II.

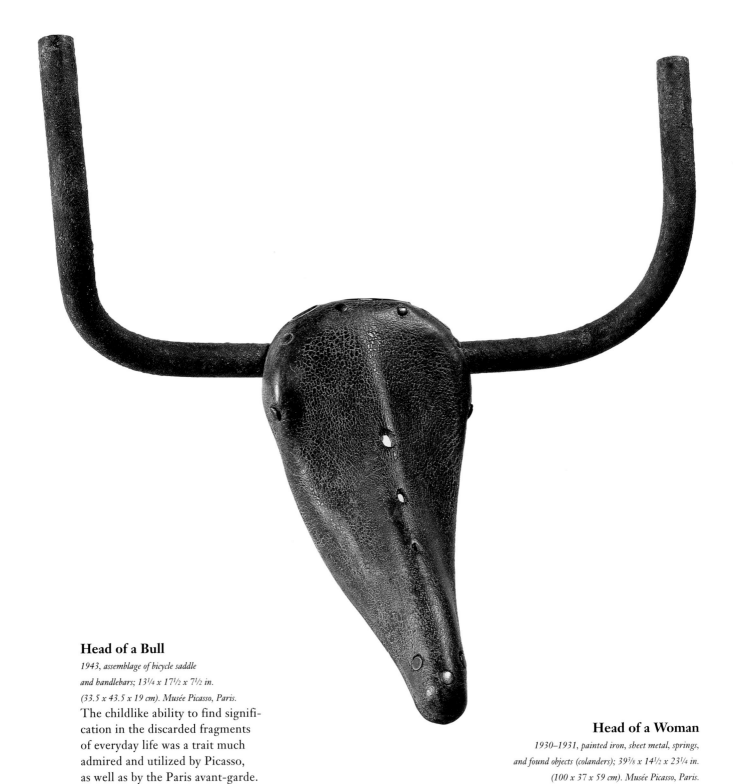

Head of a Bull

*1943, assemblage of bicycle saddle
and handlebars; 13¼ x 17½ x 7½ in.
(33.5 x 43.5 x 19 cm). Musée Picasso, Paris.*

The childlike ability to find signifi-
cation in the discarded fragments
of everyday life was a trait much
admired and utilized by Picasso,
as well as by the Paris avant-garde.
The conversion of discarded parts of a
bicycle clearly places art in the vision of
the artist as much as in the object itself.

Head of a Woman

*1930–1931, painted iron, sheet metal, springs,
and found objects (colanders); 39⅜ x 14½ x 23¼ in.
(100 x 37 x 59 cm). Musée Picasso, Paris.*

There is a specific seriousness behind the
humor of utilizing kitchen colanders for a
human head in this work. Picasso had
begun using found objects in sculpture as
early as 1914 in order to challenge
assumptions about their very nature.

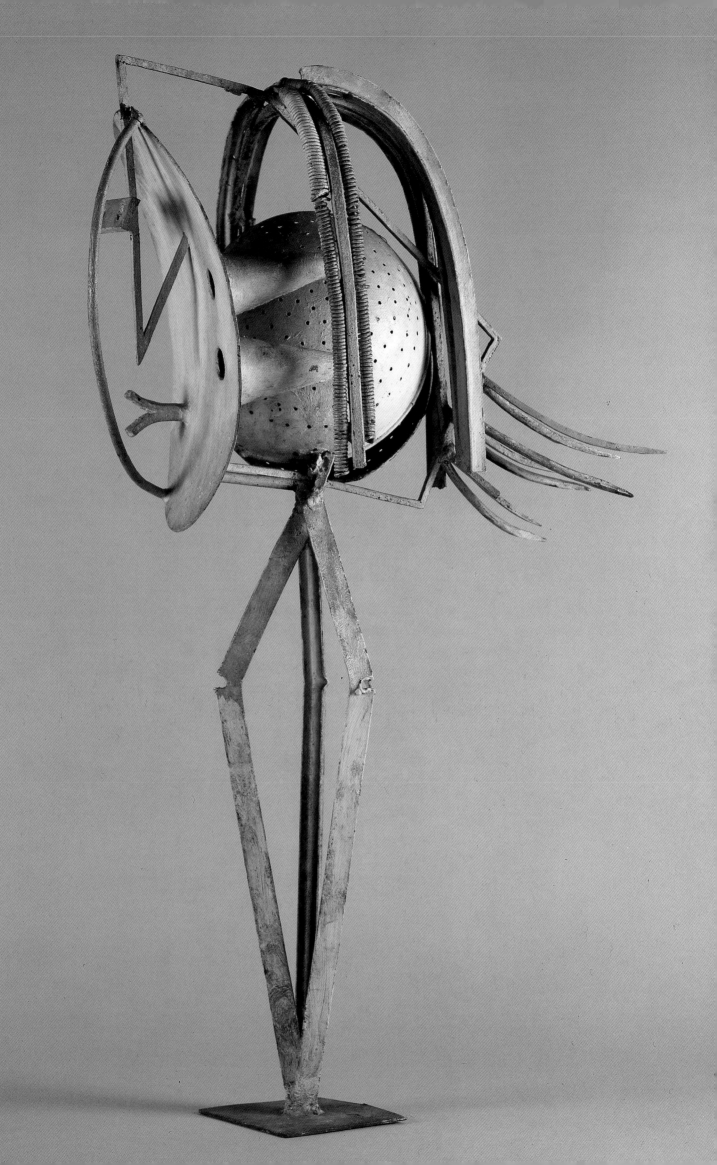

Woman with Baby Carriage

1950, bronze (after assemblage of cake pans, terra-cotta, stove plate, and stroller); 80⅛ x 57 x 24 in. (203.2 x 144.7 x 60.9 cm). Hirshhorn Museum and Sculpture Garden, Smithsonian Institution, Washington D.C.

The birth of two children through his union with Françoise Gilot seemed to have prompted in Picasso's work ever more of the child-artist at creative play.

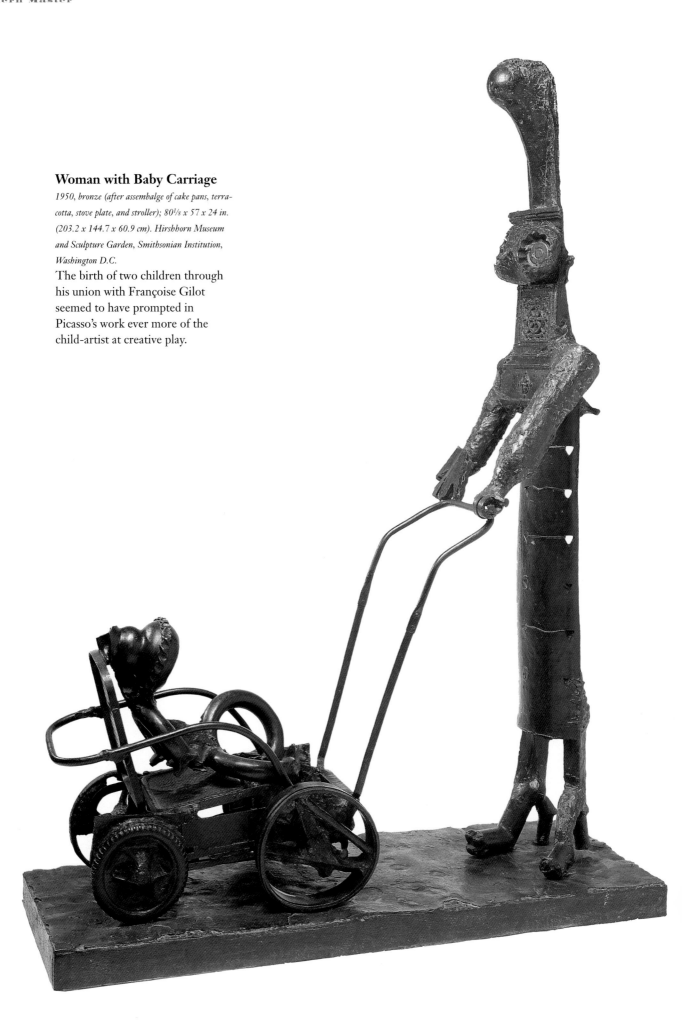

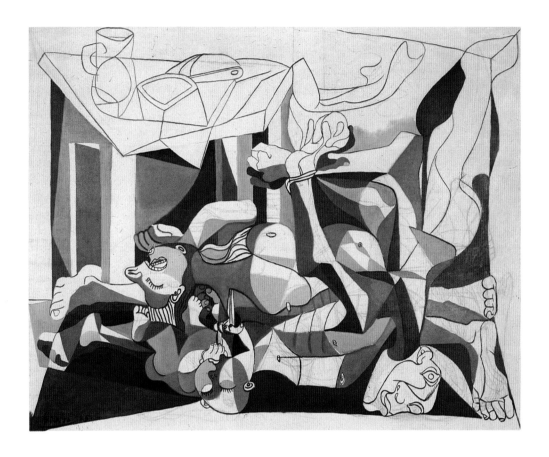

The Charnel House
1944–1945, oil and charcoal
on canvas; 78⅝ x 98½ in.
(199.8 x 250.1 cm). The Museum
of Modern Art, New York.
A pendant to Guernica,
this canvas was offered
as a memorial to the
many atrocities of World
War II. Picasso claimed
he was influenced in
the completion of the
work by the release
of photographs of the
Nazi internment camps.

issue was in the finding rather than in the search. Certainly the assemblage of cake pans and stove plates with an actual baby stroller, now all cast in bronze for the life-size *Woman with Baby Carriage*, was a literal transcription of his ideas. This sculpture was likely inspired by either or both of his two new children, Claude and Paloma. Picasso had become a father again in his mid-sixties.

The Later Years

In Paris during the war, in May of 1943, Picasso met a young painter named Françoise Gilot. She visited the studio for several months, left town, but then returned in November. Perhaps under her influence, Picasso returned once again to painting. As her visits resumed her portrait began to appear in his drawings.

Developments in the war, however, took precedent. Street fighting in mid-August of 1944 moved Picasso into the apartment with Marie-Thérèse and Maïa. Paris was liberated that same August, with mixtures of

sadness and celebration. Several of Picasso's Jewish friends had been arrested and lost their lives in the concentration camps, or shortly thereafter. The first photographs of the atrocities were seen in mid-1945, as Germany surrendered. Under these circumstances Picasso produced a smaller pendant painting to *Guernica* in 1945. Its title, *The Charnel House*, evoked the death camps, and the artist alluded to the war photographs as a source even though the work, begun in 1944, was well developed by that time. The pile of tied and dismembered bodies was painted in the same stark colors as *Guernica*, but the angularity and protest was missing. Their deaths were a completed act, the painting a quiet memorial.

On the other hand with the liberation came a revived sense of life and nowhere was it more active than in Picasso's studio, which became a visiting place for everyone from departing military personnel to the literati of England and the United States. Picasso and his art had represented, in an almost

archetypal sense, freedom and creativity even prior to the war but even more so now. Picasso appeared to welcome all comers and agreed to participate in his first official French public salon, the *Salon de la Libération*, where the artist was given his first official French government recognition with his own room. However, all was not smooth sailing. There were demonstrations at the salon against his work and his politics by more conservative forces. Picasso had followed his old friend Paul Eluard into membership in the Communist Party four days after the salon opening.

Dark tonalities remained in Picasso's works from 1945, vying with the brighter colors. By July of that year he bought a house for Dora Maar but began keeping Gilot as a mistress with much of the familiar complications for his personal life. A year later they began living together and the *Woman-Flower* of 1946 was the first in a series symbolizing their lives together. A year later their son Claude was born, and in 1949 their daughter Paloma, named in Spanish for the dove of peace that Picasso had designed.

In the interim they had moved to a villa in the hills above Vallauris, where in the early 1950s he painted canvases celebrating his family life. Picasso by this time had become an international emissary for the peace movement and traveled widely as an intellectual. He bitterly opposed the Korean War and the American intervention in it. By 1952 his relation with Françoise was deteriorating and in 1953 she took leave of the villa with the children. The eventual publication of her memoirs, *Life with Picasso*, published in 1964, caused a split in the family between father and children.

In the summer of 1953, while traveling in Spain with his daughter Maïa, Picasso met Jacqueline Roque, who would become the sixth significant woman to enter his life. Her portraits appeared in 1954 at about the time they began living together. They were married in 1961 and she survived his death in 1973 at the age of ninety-two.

In the 1950s Picasso's close friends were of a generation for which he attended a number of funerals. History had always been an integral part of Picasso's life and in 1950 he began painting works after historical artists he admired, such as, in additon to Vélazquez, Gustave Courbet, and El Greco.

Perhaps it was mortality or, rather, immortality that was on his mind when he began to paint over forty variations of *The Maids of Honor* (*Las Meninas*) by the great Spanish Baroque painter Velázquez, whose works he had first seen in the Prado as a youth. History had always been an integral part of Picasso's life and in 1950 he began painting works after historical artists he admired, such as Velázquez, Gustave Courbet, and El Greco.

In the 1950s and 1960s Picasso also painted free variations of Nicolas Poussin, Lucas Cranach, and Eugene Delacroix, but nothing on the scale of *Las Meninas*. Many of these were painted in his studio at his villa La Californie, overlooking Cannes. All of them were marked by brilliant color and new organizations in the artist's continuing spirit of invention. All of them, too, in some way embodied Picasso's private reflections on the personality and the myth he had long since become. But this was not the end. The amazing productivity that is part of the Picasso legend produced a steady stream of works in a variety of media, themes, forms, and styles which continued until his death.

No single work can summarize the lifetime of a tremendously prodigious talent, but the exuberant, expressionist works of Picasso's late years present a new, direct if brutal vision of life. They portray the survival not simply of a painter or even a legend. Rather, they show doubts and uncertainties realized in both a passing from and a passage through the physical world. Here, within uncertainty, one finds Picasso's primal certainties of birth, death, sex, and self; apparent "natural" certainties for so much of his life and work.

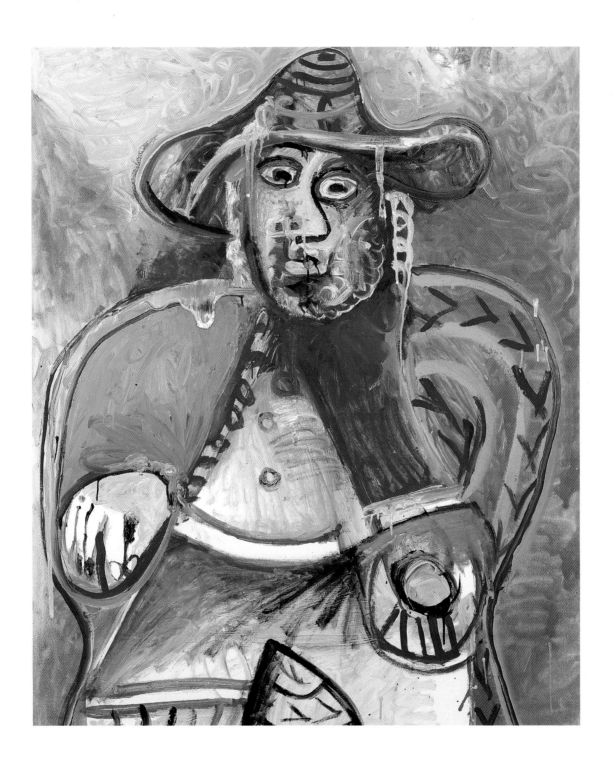

Seated Old Man

1970–71, oil on canvas; 56⅓ x 56⅛ in. (144.5 x 114 cm). Musée Picasso, Paris.
The late and brutal candor of Picasso, often given over to a sense of
voyeuristic compensation for the loss of earlier sexual passions, also
spawned a series of expressively rendered "old men" and "cavaliers" caught
between coloristic celebrations of life fulfilled, melancholy acceptance of
the waning tissues of life, and wry symbols of love's labors lost.

**The Maids of Honor
(Las Meninas), after Velázquez**

*1957, oil on canvas; 76³⁄₈ x 102³⁄₈ in.
(194 x 260 cm). Museo Picasso, Barcelona.*
A great challenge for Picasso
was recasting the most famous
painting of his most famous
seventeenth-century countryman,
Vélazquez. The forty-plus works
in the series were donated to
the Barcelona Picasso Museum,
in memory of Picasso's lifelong
friend Jamie Sabartés.

Portrait of Ambroise Vollard

1915, pencil; 18⅜ x 12⅝ in. (46.7 x 32 cm). The Elisha Whittelsey Collection,
the Elisha Whittelsey Fund, 1947, The Metropolitan Museum of Art, New York.
Picasso's turn to naturalism came first through his beloved
medium of drawing, concurrent with his experiments
in the late phase of Synthetic Cubism. The portrait is
of his gallery dealer and friend, whom he had painted
earlier in an Analytic Cubist style during the spring of 1910.

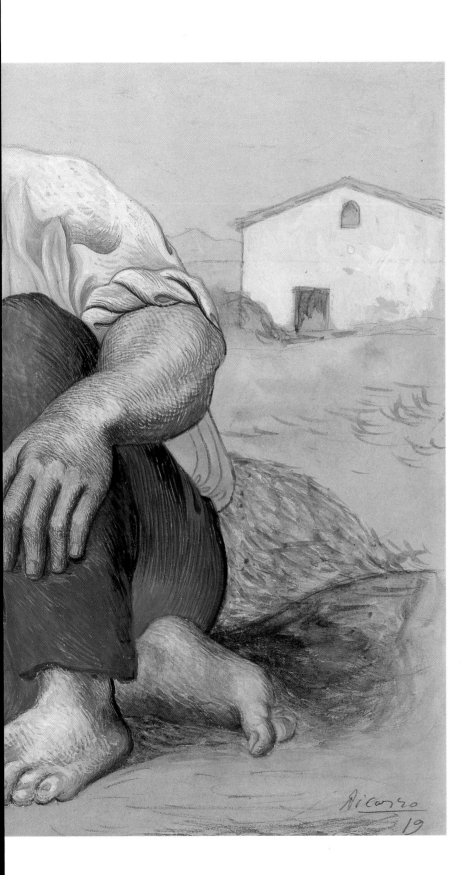

Sleeping Peasants

1919, tempera, watercolor, and pencil;
12¼ x 19¼ in. (31.1 x 48.9 cm).
Abbey Aldrich Rockefeller Fund,
The Museum of Modern Art, New York.
Typically, through small
studies and drawings Picasso
anticipated his own change
in style to the more robust
and physical figures he
developed in the early
1920s. This colorful work
in tempera, watercolor, and
pencil has openly erotic
overtones equated with a
natural life in the country.

Painter and Model

1928, oil on canvas; 51¹/₈ x 64¹/₄ in.
(129.8 x 163 cm). The Sidney and Harriet Janis
Collection, The Museum of Modern Art, New York.
The subject seen here is a theme
Picasso returned to throughout his
life. A humorous turn is evinced as
the Cubist painter draws a natural-
istic profile of the Cubist model.

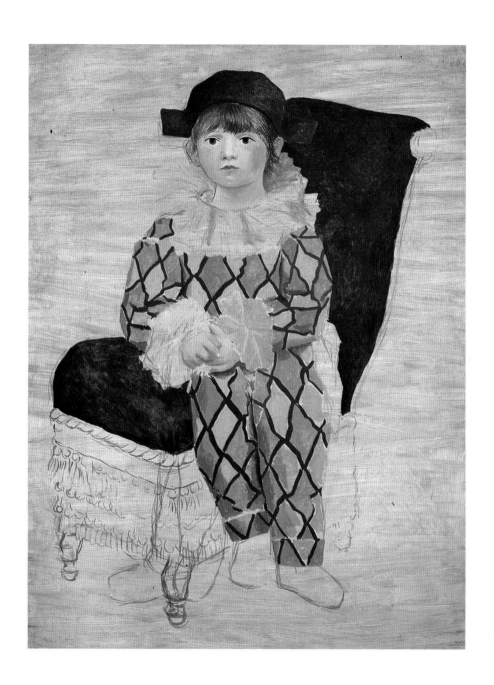

Paulo as Harlequin

1924, oil on canvas; 51¼ x 38⅜ in. (130 x 97.5 cm). Musée Picasso, Paris.
Among Picasso's many portraits of his first son few are as
endearing as those of Paulo dressed in costumes from the theater
figures of his father's Rose Period—Harlequin and Pierrot—which
had previously served Picasso himself as surrogate self-portraits.

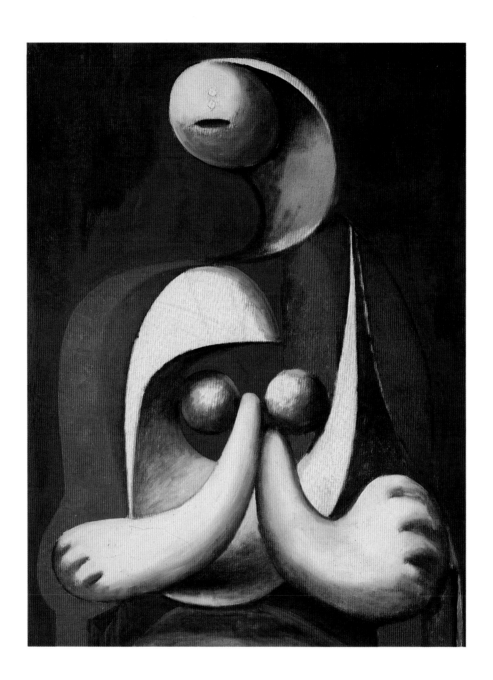

Woman in Red Armchair

1932, oil on canvas; 51¼ x 38¼ in. (130 x 97 cm). Musée Picasso, Paris.
Part of Picasso's continuing series of the female body in the early
1930s, this work came at a time when the painter was illustrating
Ovid's *Metamorphoses* and itself seems a final transition of the figurative
tradition through a combination of Surrealist and abstract styles.

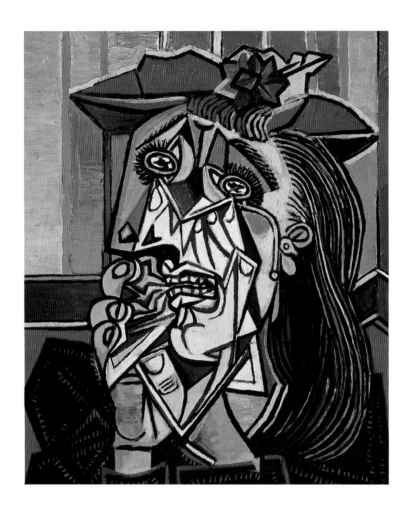

Weeping Woman (Dora)

1937, oil on canvas;
23⅝ x 19¼ in. (60 x 49 cm).
Tate Gallery, London.

After *Guernica*, as after *Les Demoiselles*, Picasso continued to explore the implications of an expressionist form of Cubism. His series of weeping women has come to symbolize a general sense of agony.

The Red Armchair

1931, oil and enamel on plywood; 51½ x 39 in. (130.8 x 99 cm).
Gift of Mr. and Mrs. Daniel Saidenberg, The Art Institute of Chicago, Chicago.

In 1927 Picasso met Marie-Thérèse Walter, who remained his lover and eventually bore him a daughter. Her likeness appeared regularly in his art, although he kept her identity secret for many years.

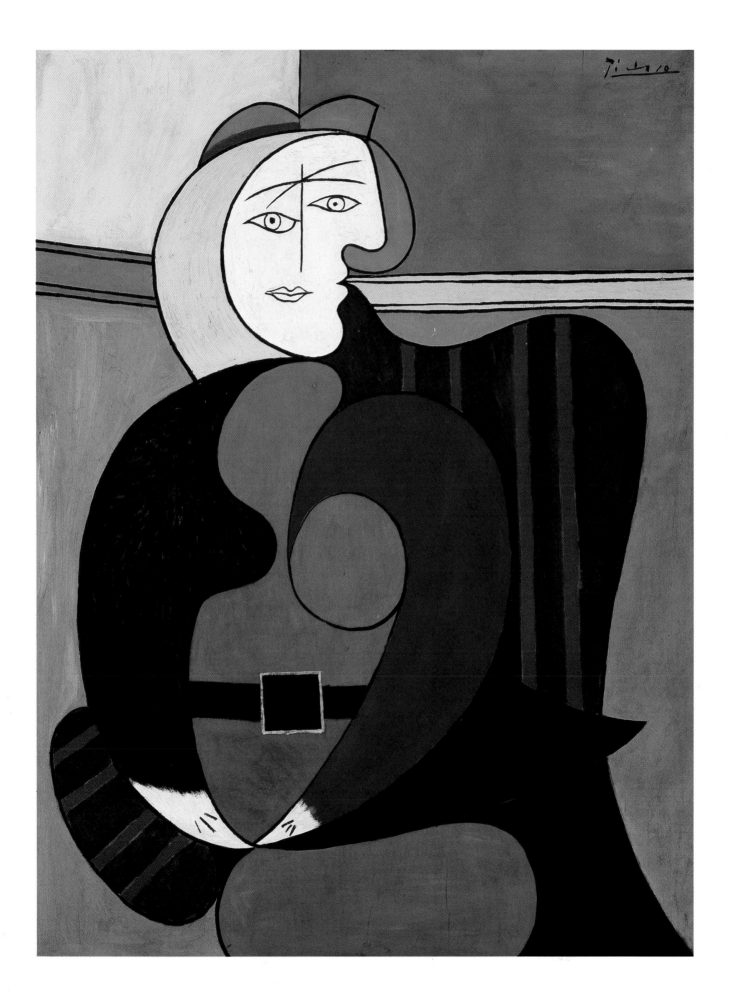

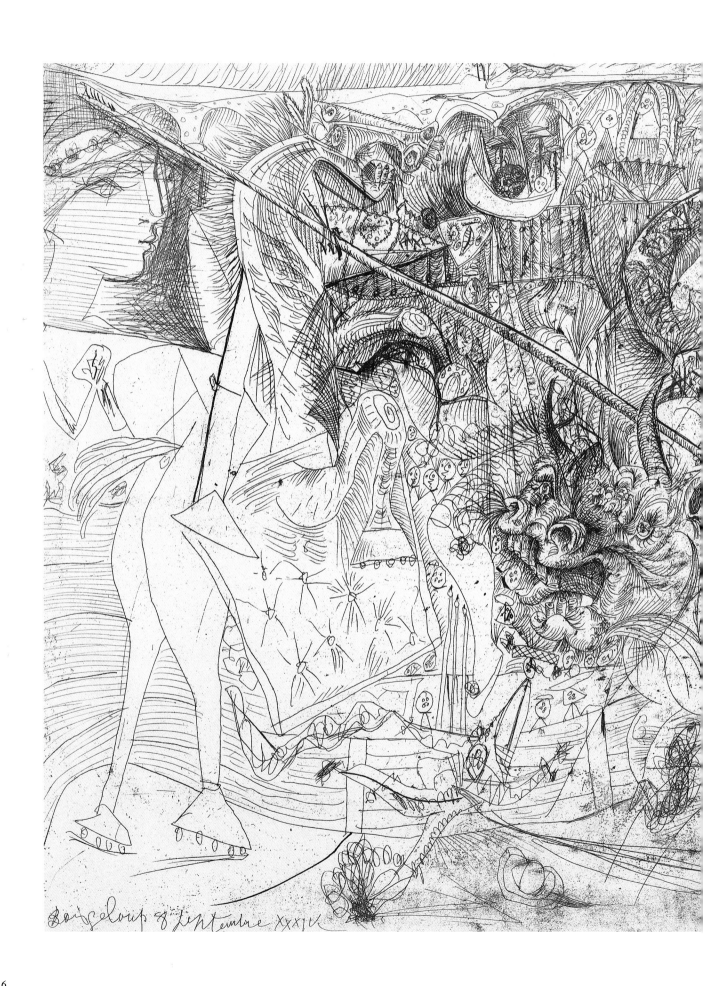

Bullfight

1934, etching; 19⁷/₁₆ x 27¹/₁₆ in.
(49.4 x 68.7 cm). Acquired through
the Lillie P. Bliss Bequest, The
Museum of Modern Art, New York.
At various times Picasso
shows the close relation
between the bull and
the minotaur, as here in
the face of this monster,
and forces the "bullfight"
into a pit of gore, may-
hem, and eroticism; a
primal battle between sexes.

117

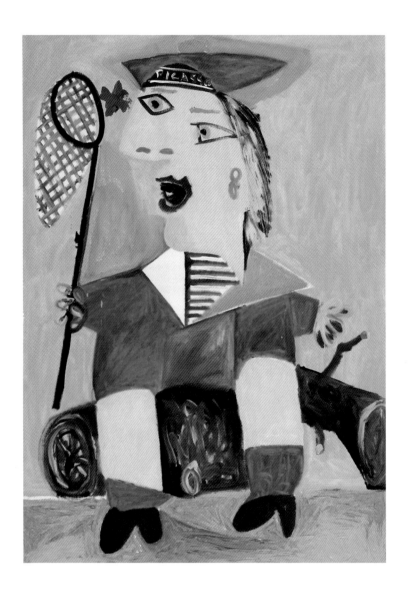

Maya in a Sailor Suit
1938, oil on canvas; 47⅞ x 34 in.
(121.6 x 86.3 cm). The Museum
of Modern Art, New York.
Picasso painted fairly
formalized portraits of his
daughter (born in 1935 of his
union with Marie-Thérèse)
as he had of his son Paulo
in the 1920s. His crude
signature on her cap argues
for Picasso himself as a
child, and supports his later
agreement that this, too,
was a surrogate self-portrait.

Head of a Woman
1932, bronze; 50⅝ x 21½ x 24⅝ in. (128.5 x 54.5 x 62.5 cm). Musée Picasso, Paris.
Typically Picasso worked in several styles simultaneously in painting
and in sculpture. This portrait of Marie-Thérèse Walter is part of a
series based on her face cast in the more traditional medium of
bronze, while at the same time Picasso was pioneering welded iron.

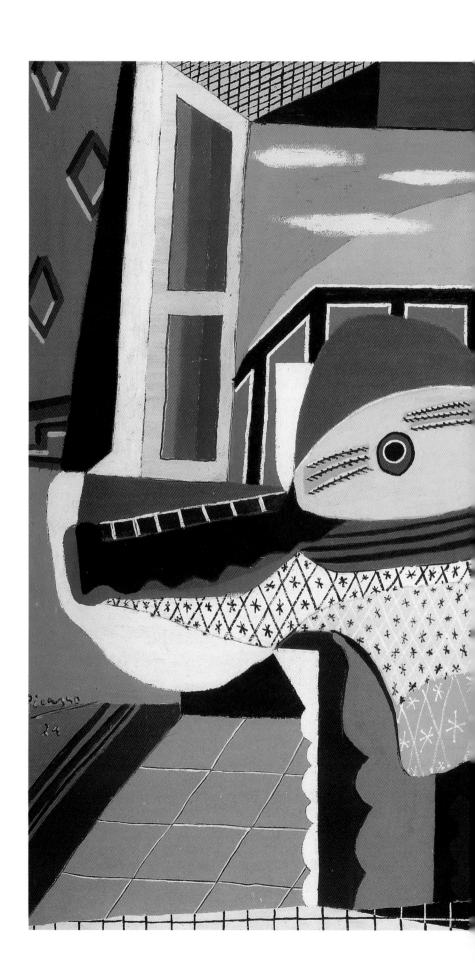

Mandolin and Guitar

1924, oil and sand on canvas; 55⅜ x 78⅞ in.
(140.6 x 200.2 cm). The Solomon R.
Guggenheim Museum, New York.
Always present, in the 1920s
Picasso's Cubist language
was elaborated into light-
filled and colorful compo-
sitions. Seldom is the Cubist
vocabulary so brilliant and so
bold as in this series of still lifes.

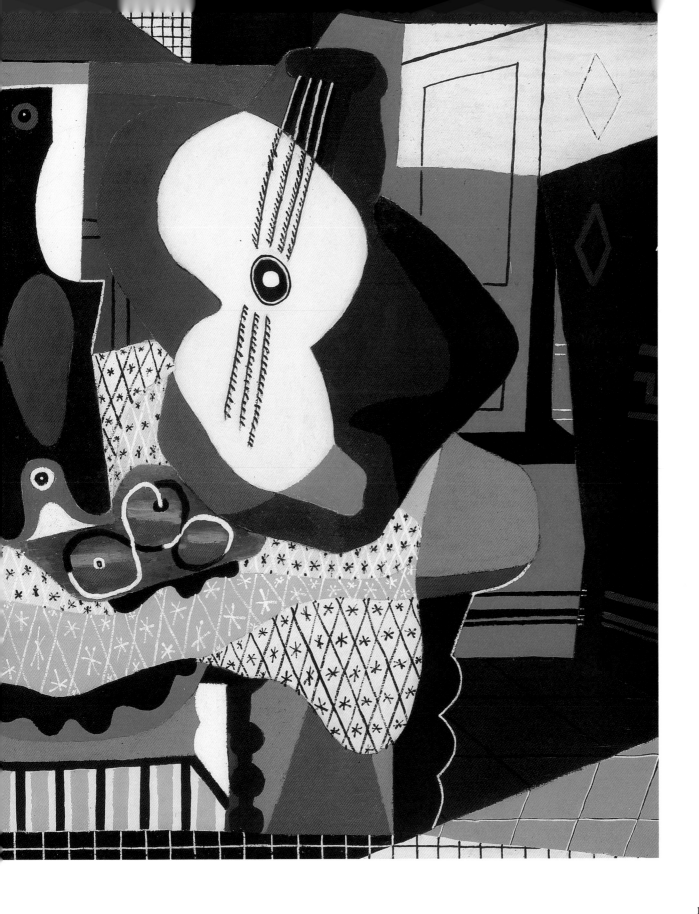

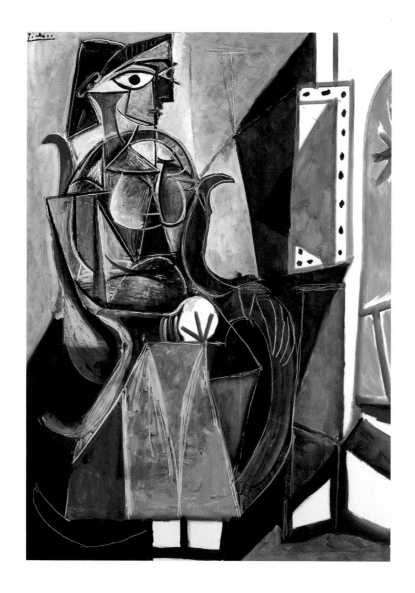

Woman by a Window

1956, oil on canvas; 63¾ x 51¼ in. (162 x 130 cm). Mrs. Simon Guggenheim Fund, The Museum of Modern Art, New York.

Jacqueline Roque was the last companion to Picasso beginning in 1954, and eventually became his second wife. She was the model for many of the luxurious female nudes in his later years and their relationship was, by most accounts, far less tempestuous due to her sense of devotion and quiet grace.

Seated Woman (Françoise)

1946, oil on canvas. Gift of Joseph Pulitzer, Jr., St. Louis Art Museum, St. Louis, Missouri.

Françoise Gilot became Picasso's companion in 1946, and is one of the few women to continuously remain independent of him. With their children, Claude and Paloma, Picasso totally immersed himself into a child's world, but we sense some of the independence of Françoise in this painting from a time when their relation was closing.

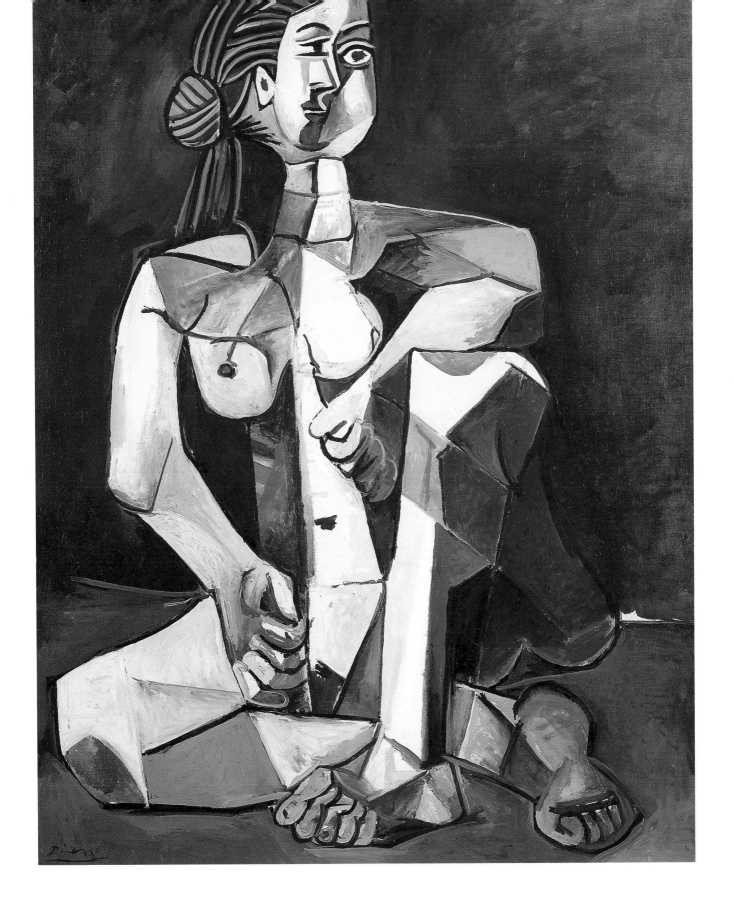

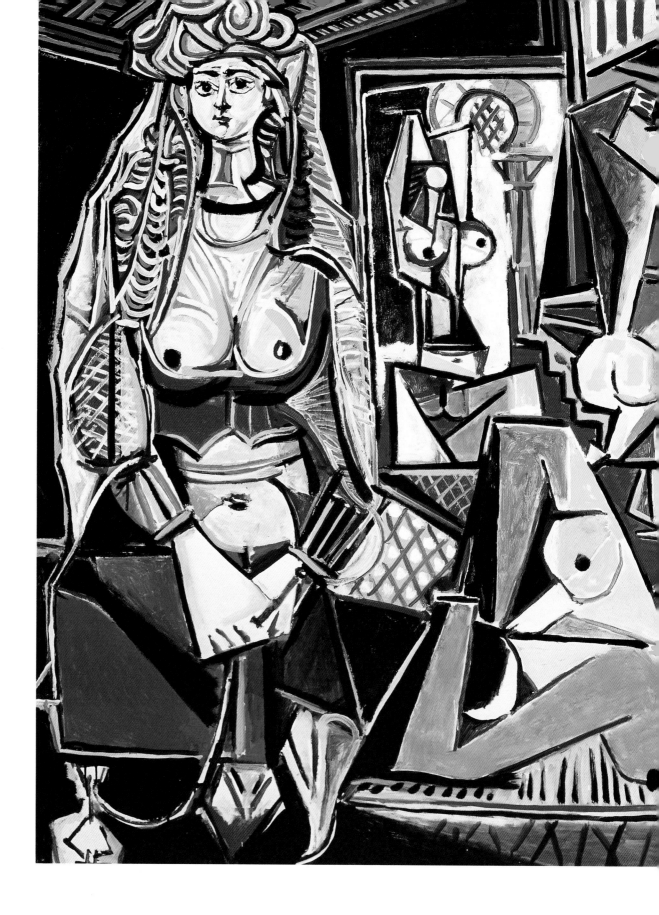

**Women of Algiers,
after Delacroix**

*1955, oil on canvas; 44⁷/₈ x 57¹/₂ in.
(114 x 146 cm). Collection of Mr. and
Mrs. Victor W. Ganz, New York.*
Eugene Delacroix was
considered the foremost
colorist of the Romantic
period of ninteenth-
century France, and his
painting based on women
seen in North Africa the
epitome of the modern
odalisques. Picasso could
not resist such a challenge.

125

Picasso, His Work, and His Public

1968, Plate 1 from Suite 347, state VII; etching, 15⁵⁄₁₆ x 22⁵⁄₁₆ in. (39.5 x 56.7 cm).

Gift of the Bibliothèque Nationale by exchange, The Museum of Modern Art, New York.

The late work of Picasso has yet to be fully explored but in his eighties he
approached his life through images of revealing candor. This plate, from a
series of etchings, shows the aged Picasso looking onto a life of the circus
and implied sexuality that had been such integral, engaged elements in his life.

Mother and Child

1971, oil on canvas; 63¾ x 51¼ in. (162 x 130 cm). Musée Picasso, Paris.

Women played a monumental role in the personal and artistic
life of Picasso, and maternity was one of the painter's earliest
themes. Here the mother poses much like the Madonna with
the Christ child or some primitive Eve open in her sexuality.